A Needle Walks into a Haystack

Koenig Books and Liverpool Biennial

Director's Foreword

Sally Tallant

This book is published on the occasion of Liverpool Biennial 2014. Bringing together a wide range of contributions, it is edited by Mai Abu ElDahab and Anthony Huberman, the co-curators of the Biennial exhibition *A Needle Walks into a Haystack*, with Camille Pageard, whom they invited to be co-editor.

A Needle Walks into a Haystack reflects on how notions of intimacy, delinquency, and inefficiency inform and permeate many contemporary art practices today. This publication is not intended as a catalogue or documentation, but as another 'site' of the exhibition, locating a similar spirit in the work of cultural critics, novelists, philosophers, poets, and others who work with the written word. The contributors were asked to respond to and extend specific texts, references, or ideas that informed the process of conceiving the exhibition itself.

Liverpool Biennial is deeply connected to the city of Liverpool and unfolds through a year-round programme of research, education, and artists' projects. Every two years guest curators join the conversation, and for 2014 Mai Abu ElDahab and Anthony Huberman were invited to curate the Biennial exhibition. They have worked with each other and with the Biennial team to curate a show that unfolds across specific sites and places in the city as well as in this publication. The exhibition *A Needle Walks into a Haystack* brings together historic and contemporary material while continuing the Biennial's tradition of commissioning significant new artworks.

It is a privilege to have the opportunity to work with the city as a context, and the Biennial's ambitious project is only possible because of the many partnerships and collaborations that underpin the arts ecology of the city and region. I am grateful to Mai Abu ElDahab and Anthony Huberman for creating a thoughtful, ambitious, and challenging exhibition, programme, and publication. They have worked closely with curators and partners in the city, and they have brought a new perspective to the situation that will have a lasting impact on our work and thinking.

A project of this scale is only possible because of the hard work of many individuals. I would like to thank the Liverpool Biennial team, including Rosie Cooper, Project Curator, who has worked closely on all aspects of the exhibition and also co-curated the James McNeill Whistler exhibition at the Bluecoat; Vanessa Boni, Public Programmes Curator, the managing editor of this publication, who has also produced all of the performance work and public programmes; Polly Brannan, Education Curator, who works tirelessly to ensure that all of our work is accessible to and engages the communities and people of Liverpool. I am especially grateful to Francesca Bertolotti, Head of Production, who has made sure that the exhibitions and commissions have been produced

to the very highest level. I am also thankful to Ellen Greig and Simone Mair, Assistant Curators, for their support.

I am indebted to the team behind this publication, including Sara De Bondt and Mark El-khatib, who have designed it with precision and care. I am also grateful to Koenig Books, our publisher, with whom we are proud to be working for the first time. Very special thanks are due to those whose thoughtful contributions make up this publication: David Antin, Abraham Cruzvillegas, Keren Cytter, Angie Keefer, Hassan Khan, Karl Larsson, Eileen Myles, Lisa Robertson and Matthew Stadler, the late Edward Said and George Szirtes.

I would like to thank each one of the many individuals in our partner organisations, without whom the Biennial would not be possible: Bluecoat Artistic Director, Bryan Biggs and Curator, Sara-Jayne Parsons; FACT Artistic Director, Mike Stubbs and Project Producer, Ana Bottela; and Tate Liverpool Artistic Director, Francesco Manacorda and Assistant Curator, Stephanie Straine.

I would also like to thank all of our supporters. The continued support of our principal funders, Arts Council England and Liverpool City Council, has been essential to the ongoing ambition and success of the Biennial, The European Regional Development Fund and our founding supporter, James Moores, without whose support the Biennial could not exist. I thank our supporters, including Bloomberg, Hope Street Hotel, Boodles, The Nadler Liverpool, Titanic Hotel Liverpool, Premier Apartments, Piccolino, Restaurant Bar and Grill, What's at Sixty Two, Titanic Hotel Liverpool, Lonmart Insurance and Jayhawk Ltd.

Finally, I would like to recognise the support of our cultural partners and project funders: Metabolic Studio, Kadist Art Foundation, SALT, the Flemish Authorities, the Granada Foundation, Creative New Zealand, the Henry Moore Foundation, Ernest Cook Trust, Fluxus, Goethe Institut, Institut für Auslandsbeziehungen, the Stanley Thomas Johnson Foundation, the Swiss Cultural Fund in Britain and Acción Cultural Española. I am deeply grateful to the Liverpool Biennial patrons, especially the Chair of the patrons group, Alex Wainwright and the circle of galleries, without whose enthusiasm and support nothing would be possible.

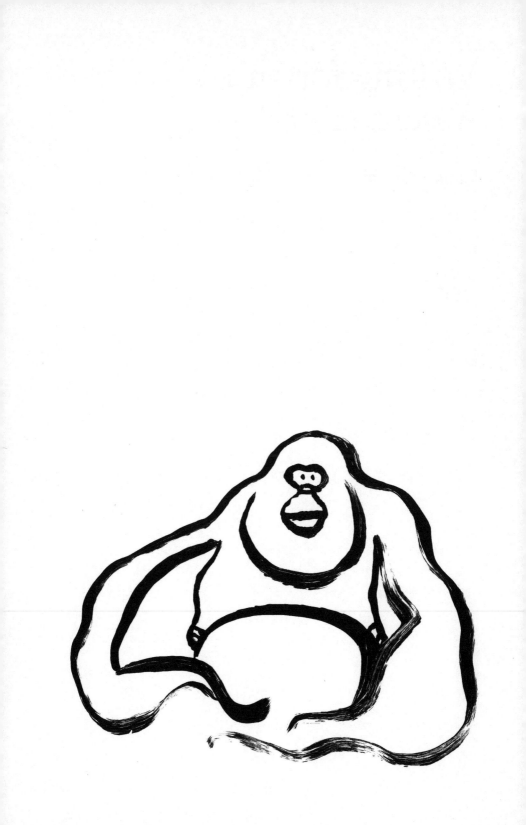

Writing for an Absent Friend

Camille Pageard

At the turn of the 19th century, German art historian Friedrich Schlegel published a series of letters addressed to an anonymous friend living in Dresden.[1] Recently arrived in Paris, the author endeavours to introduce his friend to the new collection at the Louvre through a solitary, fictional visit to the museum. Guiding the eyes of the reader, Schlegel moves around the museum, successively comparing each work. The exhibition becomes the support for an analysis in which the gaze and its literary transcription take centre stage, and the movement from one painting to the next becomes a pretext for the elaboration of a discourse on art. This classic case study in developing genres of artistic discourse can be compared and opposed to a text written by Schlegel's older brother August Wilhelm and his wife several years earlier.[2] After visiting a Dresden museum, August Wilhelm proposes a "conversation" in which the two brothers and a friend, in a perfectly pre-romantic atmosphere, sit on the grass by the water and try to discuss descriptions of the paintings that one of them has written for an absent friend. As they reflect on the works, they also consider the central role of language and whether it is capable of accounting for pictorial experience. This conversation, which one may imagine as both relaxed and extremely serious, produces an erudite, passionate dialogue during a quiet afternoon, amid remembrances of the visit, contradictory viewpoints, and questions about the efficiency of the textual transmission of a visual experience. Indeed, this text is deliberately situated between being immersed in the experience of art and being withdrawn from it, between being a literary narrative and employing a specific form of address that characterises artistic discourse.

This book, which accompanies the exhibition *A Needle Walks into a Haystack*, recreates a similar type of situation. It is the site for a polyphonic discussion in which the works of art have virtually disappeared in favour of dialogues, studies, fictions, and digressions. Each of these texts, written by artists, critics, curators, or poets, tries to find a specific voice and mode of address through particular daily moments bearing a certain relationship with what one may call the place of artistic discourse. Each text locates these barely noticeable moments when language and thought appear, elaborate, and start taking on a communicable form, or when thought's private character joins public communication. They consider the ways in which an epistolary exchange, a systematic documenting of events, or a friendly discussion over drinks may be a place for reflecting on a work of art, on the creative process, on literary history, or on the elaboration of an idea.

If the exhibition is a place to meet with a work of art, it is also a place in which this meeting leads to a reflection that emanates from the artist's thought. For an artist and for a writer, the place of artistic discourse and reflection is

not only the studio or keyboard, but also the moments of boredom or loneliness, the time spent shopping on the internet, the struggle to remember a haunting fragment from a book, or incomprehension when faced with public or political events on television – all of which relate to the attempt to recall or understand something while the clock keeps ticking. Here, these delinquent moments are considered the productive tools for written communication, as sources for literary and reflexive experiments.

Following the American poet David Antin's 1965 essay "Silence/Noise", the texts in this book are committed to the act of writing as a way for subjectivities to communicate publicly: "By definition language is public. There is no such thing as private language. There are only linguistic communities of various size …"[3] Antin proceeds to say that any encounter with any entity – humans, objects, works, concepts – is a series of confrontations situated in and bordered by the context of their utterance and the silence from which language emerges. Further on, he adds:

Theorem: There is no language outside its speakers

Corollary: Differences in language are differences in the ordered realities of their speakers[4]

In more general terms, language is linked to the contexts of its transmitters and of its receivers – social life, first of all, but also the technology allowing the transmission of ideas, the nature of discourse, the authority of institutional, political, and historical narratives, or the very space from which discourse emerges, and so on. If we consider these factors as natural characteristics of language, then we can understand the transmission of information, ideas, thoughts, or sensations as being intrinsically mediated.

In her text "Introductory Notes on an Ecology of Practices", Belgian philosopher Isabelle Stengers evokes this dialectic between the context of utterance and the transmission of discourse by using Gilles Deleuze's term *milieus*, where the act of communication may be understood as the attempt at communicating between two entities belonging to different *milieus*. She therefore infers, again using Deleuze, that "only what diverges communicates,"[5] which involves a specific definition of "diplomacy" that is not about "common language" or "intersubjective understanding" but about "a matter of construction among humans constrained by diverging attachments, such as belonging."[6]

Mediation through language is thus not to be understood as a filter or a process of explanation, but rather as a transfer, a confrontation, a translation, a conviction, or a persuasion. This type of mediation may be qualified as a mediation of discord, where the encounter with the object of reflection as well as with the audience to which the transmitter addresses him/herself is the source of a dynamic economy of everyday, poetic, artistic, and political discourse.

Starting from these two ideas (Antin's and Stengers'), a large part of what we call communication turns out to be utterances within an incommensurable network of intense dynamics between "entities". Our "ecology of practices" may then be summarised as a thought process simultaneously proceeding from inside and outside the milieu, through the mediation of language both common and discordant. So how may a book or text account for voices that are as private as they are public? How may an idea be expressed or an argument solved if each speaks with his or her own words? How may we tell a story, share a collective memory, or understand a public address without a common language? In order to acquire a shared understanding, there must be a mutual agreement on the rules of the exchange, but what happens if these rules are illusory, twisted or corrupted?

A Needle Walks into a Haystack raises some related questions about where and how private life ends and public life begins, but this book is necessarily engaged with the specificity of how these questions relate to communication via language. It seeks to gather under these questions a heterogeneous community of authors and of points of view.

The three texts included in the first part look at the nature of public address and discourse – who we talk to and how. More precisely, Lisa Robertson and Matthew Stadler, as friends and collaborators over many years, wonder if an exchange of letters could be both intimate and acerbic, and whether it is the right place for an analysis of a politic of writing. Hassan Khan revisits and challenges one of his own previously published texts and asks how the discourse of the malevolent thinker contributes to enforcing specific systems of knowledge. An edited transcription of Edward Said's BBC lecture series from 1993 asks whether the intellectual has to address authority "as a professional supplicant, or as its unrewarded, amateurish conscience."

The second part responds to how creative writing can be a type of daily discourse, and addresses the idea of what we may call the productive inefficiency of the everyday. It begins with a short republished text by George Szirtes about how the work of the translator invades his daily life. Putting on the guise of a teller of detective stories, filmmaker Keren Cytter writes about how a psychological interiority can be connected to the compulsive recording of domestic events. Artist and poet Karl Larsson performs an extended observation of a single piece of furniture, which culminates in a personal vision of a "philosophy of furniture".

Finally, the last part engages a series of discussions about the specificity of a literary experience, and its three texts look at how a writer's subjectivities, when confronted with texts, language or a community of writers, are involved in the process of writing, reading, or re-reading his/her own text. The poet Eileen Myles asks how an author deals with the connections between memories of real-life past and present events and a history of poetry and writing. The artist and writer Angie Keefer reflects on how, when confronted with an unknown author, one can experience an ambiguous process of familiarisation during the search for the author's voices. Closing the book is the text "Silence/Noise",

in which David Antin wonders what's happening when a writer, poet, philosopher, or artist engages in a discussion with anything/anyone in order to produce through language alone.

Interspersed throughout these texts are essays by the exhibition curators Mai Abu ElDahab and Anthony Huberman. They weave the spirit and motivations of the exhibition into the fabric of the book – keeping the exhibition itself absent, following the example set by Friedrich Schlegel and his brother August Wilhelm. All the while, a series of primates are invited by Abraham Cruzvillegas to wander through the book's pages.

This book is meant to be read at home, in libraries or in bars, but one can imagine it being brought to the river, where it would be possible to sit on the grass or on a bench, alone or with a friend, and read it thinking about the show that has just been seen.

1 Friedrich Schlegel, "Nachricht von den Gemälden in Paris" ("Description of the Paintings in Paris"), *Europa*, 1802–1805.

2 August Wilhelm Schlegel and Caroline Schlegel, "Die Gemälde. Ein Gespräch" ("The Paintings. A Dialogue"), *Athenäum*, vol. 2, no. 1, 1799.

3 David Antin, "Silence/Noise", *some/thing* 1, spring 1965, p. 60.

4 Ibid., p. 62.

5 Isabelle Stengers, "Introductory Notes on an Ecology of Practices", *Cultural Studies Review*, vol. 11, no. 1, March 2005, p. 190.

6 Ibid., p. 193.

Camille Pageard (b.1982) is a French art historian, writer and editor living in Brussels.

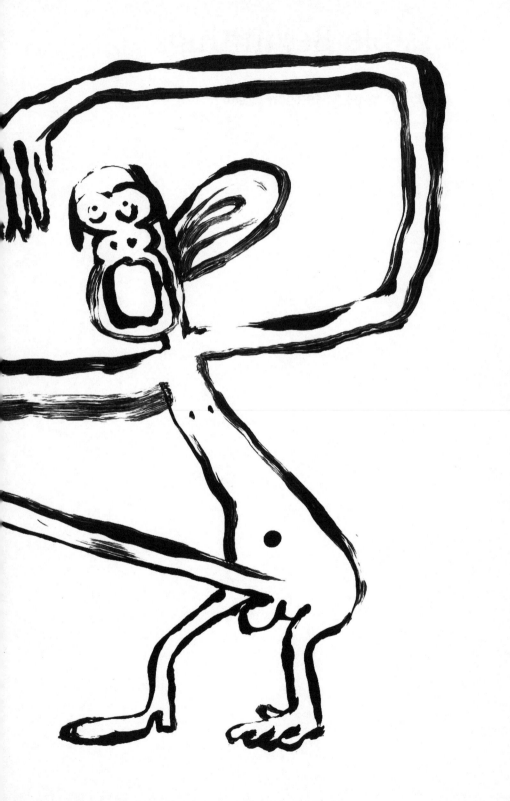

Possible Beginnings

Lisa Robertson and Matthew Stadler

Dear Mmmtttjbw,

Returning from an afternoon visit to Courbet's painting *The Artist's Studio*, we walked across the Passerelle Solferino as dusk gathered and suddenly the light on the teak bridgeplanks changed the city into a familiar room where once we chatted together, sipped champagne cocktails, shared a cheerfully coloured pill, visited glass houses. We thought of your love of hotels. You were almost gnostic. We wore a pretentious coat. We wanted to use style to please you. We made style devour lucidity, turn cabins into bridges and bridges into cabins, think an impossible architecture. But it wasn't impossible. We made those cabins and we made their origins, and we called them tables or schools. We made the bridges then we camped on them and twitched in our sleep like dogs. We made rooms for reading or for bathing, on weak porches and in attics. In a way we were the anthropologists of rooms. We were anthropologists of fumbling. Then we went swimming.

How does the architect begin is what we asked, how does the astrologist begin, and the friend. And you responded that the architect begins in heartbreak. This felt believable. We've kept believing in the school that doesn't exist. It only needs a table and some stray desires.

We wanted to be fearless. For you we want to be fearless was the formulation. Was that a style?

You were the one who made it his work to decorate borders by crossing them. Against the protocols of transparency you set tables. We argued and we ate. We collected and we annotated. Books were everywhere. Soup would spill. Usually the cheese stank. Afterwards the table would be left strewn with rinds and greasy napkins and the odour of meat, the candle wax pooling, nutshells and stains. We would just leave it that way because we knew that decay and its exaggeration needed to be part of anything.

By never talking about the body we were always talking about our bodies. You sang out to your kid as he bounced on it bellybench bellybench bellybench. We ate boiled flowers. All of this was part of architecture. We lay on our belly in your attic and read Ruskin in summer.

Did any of this prepare you to enter the degradation of conditions?

Love,
OSA

Dear OSA,

I am reading *Testimony*, a book described as a "memoir by Dmitri Shostakovich".
I say "described" because I am told Shostakovich may or may not have had
much to do with its authorship, and the story it tells may or may not have
much to do with his life, as he understood and lived it. Although his was a
very public life (he appeared on the cover of *Time* magazine at the height of
WWII, dressed in his volunteer fire brigade uniform, getting ready to defend
Leningrad against the Nazis) it is difficult to attach any of his public life
firmly to his private biography, the life he understood himself to be living.

Composing and performing under Stalin for most of his creative life,
Shostakovich was obliged to "author" a great deal of writing, public speech,
and possibly also music, that was not his. He would say the words; he would
sign the letters and declarations; he would author the composition – but they
came from others, from the State. The words were effectively Stalin's. But
Shostakovich, as an internationally celebrated Soviet composer, had to lend
his face and body and voice and biography to the stories Stalin preferred.

Among other things, *Testimony* is a moving account of Shostakovich's
pleasure in being a Soviet artist. However terrible the hardships (and in his
life, as recounted in the book, they included famine, disease and the constant
threat of secret police action against him and every artist and composer he
admired) Shostakovich brims with a genuine-seeming, wry appreciation of
the special qualities a Soviet artist enjoys. They've got subject matter, for one.
They've got a purpose. What they did mattered, intensely, at the highest levels
of politics and culture, enough so that the cost of failure could be torture or
death camps.

The book is actually very funny. The stories of colleagues negotiating
freedom by trading secrets to police in public toilets, of enduring the almost
random merry-go-round of praise and censure coming from Stalin, of
mouthing platitudes in exchange for sheets of music paper to compose
on, are grim, but leavened by his wry appreciation of human folly. "His"
wry appreciation, I say, though, in fact, I don't know whose.

Who is the author of Dmitri Shostakovich's memoir? And who was the
author of his life, as he lived it? And how did he manage to live inside his work
under such intense pressure outside to shape him as a Soviet artist? I want art
to matter. Right now, I think it does. The best evidence I have is how hard it
has become to live. Your letter to me is beautiful but it is also memorial, like
something to be read at my funeral. It's all in the past tense, turning then on
the question: Did all of that prepare us to "enter the degradation of conditions"?

Yes, I think it did. And that's what brought Shostakovich to mind. He lived
a rich, long life in the degradation of conditions, and he managed to work. I like
his attitude, and his life gives me a good perspective. This is better than Stalin,
I tell myself. But who is writing my memoir?

Mmmmbdgdgey

Dear Mmmmmzbtdew,

We're on a train near NY and it's stopped. There's grey snow melting in a gravel garbage-strewn ditch beside the tracks, and past the tracks a highway, four or six lanes, medium traffic moving smoothly. It's mild. Beside the tracks a low concrete brutalist building painted cream is entirely streaked with greenish vertical stains. There seems to be offices inside. The louvered blinds are bent, irregular. Generally the ugliness is monumental. A woman in the seat ahead of me discusses Uncle Joe's failed attempt to lose weight, and Aunt Mary's cookie diet. I think that this whole thing is precisely the scene I've tried to leave for thirty-three years, the reason I live in a shack in the middle of nowhere in France. But it's funny of course. The attempt to leave is funny, and so is the cookie diet, and so are the green stains. Naturally we've always been fleeing the present, which is why we need to write about it, why we need to transform the present, call it architecture or caesura or nilling. Now the woman is talking about her cousin who used to work on interesting chemicals at Dupont, and who now for three years has been working on extending lithium battery life.

My friend Peter said to me in the car on the way to the train this afternoon why do they call it late capital, since clearly it is just beginning. When I think that this landscape outside the stopped train is the beginning I realise that my romance feeling is the refusal of memory, or the attempt to master memory. It's pointless. A man in a white shirt and clipped dark hair comes out of the stained building to smoke a cigarette and check his cell. Now the woman in the seat ahead, her voice slightly squeaking, is talking about bridesmaids, and Harriet's daughter. The comedic clarity is almost classical. These nothing events that I abhor, they're what I am. The power system on the train has failed says an announcement and a man beside me becomes angry, gets up and slams the toilet door then returns to his seat.

She passed out in Home Depot, and when she woke up, she couldn't find her kids, is the story now. She got too comfortable in her relationship. The more ornate the stories get, the more joyously the woman giggles. Trains speed past us periodically and the light dims.

Is this a scene you prefer to the Passerelle Solferino? Is this stopped present on Amtrak allegorical, like the paused scene in Courbet's image of his studio? I know how to make use of the crappy detritus because I have read Benjamin. But what if I've been faking it? I like the inhabitable fantasies you have built in your books and in your spaces, including the little studio you live in now. I liked the messy picnics. I like knowing that you are mixing your strong ginger vodka cocktail at 5 pm, just after swimming, and using the shaker you bought when Joe visited you. I do want to ritualise memory and I dislike that.

I recognise the life I believe myself to be living when I sense that this life is perceived by a friend. I don't know anything about Shostakovich, but in that double life is friendship even possible? I think you are telling me that my purple description is not something that you recognise now. But we were both in those kitchens, on those bridges. We did share the pill. Is friendship an agreement

about a style of representing shared time? Now the darkening train has been stopped on the tracks for more than two hours. I'm paused in a banal passivity, waiting for the future, which will include countless comedies like this one. At very least, I hope I can still entertain you.

And I hope you're eating well.

 Love,
 L

Dear L,

I'm clearly pushing back against something, but it isn't you. What then?
This present tense is lovely (I have ridden that train, too, and got stuck when
the power system failed) but so was OSA's gorgeous past-tense evocation.
I recognise myself and our lives in it, and it wasn't "purple". Friendship is an
enchantment with styles of representation, an open heart, more so than an
agreement about style, I think. I called it "memorial" not to mean shut away
in the past, but because it evokes memory, brings the past into the present.
But then, yes, I did tie it to my own funeral. So.

I'm angry that I'm writing this under deadline, and we should talk about
that. Like you, I recognise the life I believe myself to be living when I sense
that this life is perceived by a friend. You have saved my life, many times
now. I mean that literally. When our friendship is not with me – materially,
mentally, emotionally – I can forget how I live. I hold your language in my
head, and in my hand, to remind me. It's powerful stuff, and it powerfully
reminds me of a life I am kept from now, of borders I can't cross, of places
I am not welcome, rooms and tables where I will never rest or find pleasure.
So, maybe that beckoned my morbid associations.

I'm bedeviled both by endings and the impossibility of ending. Everything
just seems to go on and on, becoming thinner and more dispersed but never
stopping. It's like some sort of reverse apocalypse – no ending, ever. I am
drawn to flirt with destruction, annihilation, to beckon an "end" that might
be as crucial to "the life I believe myself to be living" as this ceaseless, ongoing
productivity we are both caught in. So, yes, it's getting clearer to me: maybe
I'm pushing back against productivity – or the framework that demands and
organises it – which is no small thing. It's a matter of life and death. And I'm
angry. And your friendship means the world to me.

I've read that Shostakovich's close friendships were intense and life-long.
One was with Ivan Sollertinsky, a Russian Jew who directed the Leningrad
Philharmonic. Shostakovich dedicated one of his piano trios to him in 1943
(opus 67), a few months before Sollertinsky died in Siberia. The trio has a
rich vein of klezmer music in it, which risked offending Stalin, alas no small
thing. Shostakovich's friend and patron, Mikhail Tukhachevsky, a powerful
military leader, was killed by Stalin's secret police in 1937, just two months
after Pravda condemned Shostakovich's opera "Lady MacBeth of Mtsensk",
for "formalism". The unsigned review (usually an indication that Stalin
himself had penned or dictated the words) warned the composer, "things
may end very badly."

Shostakovich was not a brave or heroic man. After the Pravda threat
and Tukhachevsky's death he abandoned the symphony he'd been working
on (the Fourth) and produced, instead, a stirring, glorious account of Soviet
might, his Fifth Symphony, with the hand-written epigraph, "A Soviet artist's
response to just criticism." It was a hit, easily his most popular work, and he
was resuscitated as a new favourite of the Stalinist regime.

How does his life speak to me? More than a double-life, he seems like a man who has fled into a hall of mirrors so the assassins chasing him can never get a bead on his real body and shoot him. The cultural economy he worked in was brutal and clear. He had to serve his masters or die. He never stood firm; he never fought battles, as did Solzhenitsyn, Brodsky, Anna Akhmatova or Nikolai Bukharin, the Trotskyist writer who endured three months of torture before agreeing to sign a confession that, when he was brought before the Great Leader to beg for his life, Bukharin retracted to Stalin's face.

Rather than fight, Shostakovich would offer whatever face he thought his attackers desired, concede defeat as quickly as possible, and return to his music – because his life was there. Or, one of his lives; he readily gave up the others – his biography, his public image, his measure in the eye of critics and contemporaries – to go on living in music. Shostakovich signed all the confessions and lived in music's capacity to outlast the system of production that had ensnared him, the Soviet cultural economy.

How is friendship possible in such a life? It's possible in music, in listening and playing, in the compositional tasks where Shostakovich sheltered the life that was his. His music was richly literary. His close friends were writers. He had a peevish distaste for other Soviet composers, especially Prokofiev. But writers were his drinking buddies, his confessors, his inspiration. He read and wrote and lived quietly with his wife and two kids. And then, when necessary, he would put on his flat, affectless face, hide behind his thick glasses, and go out to perform "the Soviet artist" whenever it was asked of him, in order to survive.

We have no Stalin. Instead, we have the market, and once again you and I are writing for it. I'm telling you things you taught me. Or Susan Briante: "The market is a parasite that looks like a nest." Our performance in the market swaps the vitality of the lives we are living for performance as producers of content as a commodity. You are part of my life; now I'm on deadline to turn those meanings into product. It can drain our writing of what it means and turn lived meaning into dead commodity. The market is no less brutal or indifferent to our lives than was its Soviet counterpart. Why should we perform our friendship on a deadline?

Of course it's all voluntary. We are good market artists – and I mean this about myself, sincerely – always responsive to a just commission. Our commissioners are never dishonest, threatening, nor parasitical. Not at all. Their transactions have been generous and honest. They're probably doing us a favour. We should be grateful there's no Stalin and we can speak about these things openly. But the fact that we can talk about the market has not made us any more free. So, now I'm being an ungrateful jerk in public. And I think I should just erase this and write a sweet reply, but it's too late for damage control. What would Shostakovich do? He'd sign the thing and read it out loud in a monotone in public. A market artist's practical response to a just commission.

With love for you, much more so than anger at markets,
Matthew

Dear MMmttgw,

Why do I spell your name that way? Because when you did, when we started corresponding a million years ago, I was touched. You wanted all those extra consonants! So you took them. Why did I start as OSA? Maybe that was like Shostakovich's thick glasses.

Pushing back is something I do understand, but so is withdrawing. Three years ago looking for cheap rent and some solitude, I went to live on the edge of fields near the crop-sprayers. I always keep trying to escape. I quit high school. I went as far west as I could when I was seventeen and lived in shacks. I started university at twenty-five. I quit that. I opened a bookstore. I closed it. I went freelance. That's when we met. You've helped me in this economy so thoroughly that a large part of my published work is there because of you. Yet, like you, I hate this economy more and more. We're constrained to produce recognisable signs on deadline. The fees we're paid to do our work have not increased in twenty years; that is, if they exist now at all. We watch our friends who chose to work in academia have their labour and livelihoods devalued to the point of ridicule. We listen to our friends who are artists say the word market as if it is possible to make this condition relevant in a thought we'd wish to have. Now because of my dawdling and my bad scheduling we're way past this deadline, so I've passively forced you to comply. There are bigger reasons to be angry though.

All this moving I submit myself to – is it escape, or nomadism in the current theoretical sense? I doubt it. It's exactly what the market constrains all of us to perform. A more and more thorough and metrical de-situation. And style, a topic I like to return to maybe too often – what difference from the branding of one's own language? Refusal always feels ludicrously Romantic, as if it were possible to still believe in an outside, when there is no outside. Everything – the weather, our immune systems, our syntax, our hormones – is conditioned to collaborate with a network so thorough that it can't be called a system any longer, because a system has closure, and a discrete partitioning of components, and this situation seems to have replaced weather itself, to become an unanswerably constant element, in the ancient sense of the word element – we have air, water, space, earth, fire – or simply the one element, capital. Capital as universal hormone. I have now used the word thorough many times. Conditioned is the wrong word too, since it suggests that there's a transitiveness to the world, that a distinction could be made between the decisive movement of abstract value towards unjust increase, and the propriety of bodies and the expressions of those bodies. No body's now different from the one element. There's no properness. Identity is the identification with the overriding element. I don't really want to use the word subjectivities, though that's the word that circulates in the seminars I teach. The question now is simply – what can each body do? Grow tumours, go into hiding? I tend to take my body into libraries when it is possible, in case ancient elements are maybe hiding there, and some kind of unquantifiable combustion or flux might suddenly transpire in the darkish stacks.

I think we both still believe that the unquantifiable combustion might happen, is already immanently sizzling in some interstice. Art and friendship might supply the infinitesimal sites – but what if even those gnarliest, least answerable volatilities have been sucked into the one element? Is that what I've done by inviting you to correspond for this publication? Is there anything left to write? The performance is awful in a certain way. But what if by staying with it we could say something that actually surprises us? I want to think that this writing's a possible frame for a clinamen. A new relationship to time can't be caused, and it can't be coaxed into being by a sentimental memorialism such as I am overly capable of reproducing. Here with my students I'm beginning to explore the idea of radical hospitality in a general economy. How can we give everything away, and expect nothing, in order to delight or to protect somebody, some bodies, strangers? Can such a giving deregulate the one element? How is it possible to welcome somebody while refusing to shore up one's own identity? I know that when I have tried to welcome you, when you needed a place to withdraw to, it made me very afraid, because you were, dear old friend, in your extreme pain, suddenly and ultimately strange to me, and I was committed to being present for this terrible strangeness. It seemed I could only fail. I would rather go towards this fear, and failure, than towards anger. Is the friend the one who unexpectedly and unintentionally brings us to face our own fear and incapacity? I am a very fearful host. There's something about my relationship to writing in that statement, as well as my perception of love.

Yours, epicurean,
Lisa

Dear Lisa,

What a rich and welcome letter. I want to start with that image of strangeness, when I showed up at your door as a stranger, two decades into our friendship. I remember it so well. I had become strange to myself then, too. In terms of the "one element" you talk about – and I think that is a better naming than the word "market" (implying primarily an economic condition) or "capital" (the same) or "alienation" (as if the problem was ours) – events in my life then had suddenly left me exposed to the direct address of the one element. Your description, "a network so thorough it can't be called a 'system' any longer, because a system has closure," rings true.

I'll define it this way – the one element is whatever degrades the lives we know ourselves to be living, titrating them into disembodied fragments, alienates the fragments from us, and puts them into the service of ends we do not understand nor, often, even know. It is something like what Jacques Ellul called "technique" and it has exactly the totalising properties you describe. This one element had turned to address me directly and claim dominion over my body; not just my productivity, my writing, my profitable interactions. And I refused to accede. Which is when I came to you, dear old friend. I was strange then because I was fleeing from my own body. I think you remember me hiding inside absurd layers of winter clothing, behind a face of panic that must have looked impenetrable.

I've seen the same thing happen to homeless people and people without papers. Their abjectness is sometimes simply a determined effort to flee the site that is under attack, which is their own bodies. I have been through hard times, so I'm apt to exaggerate some of my own suffering; but I think it is legitimately the subject of our letters. My experience of attack legitimately opened a window onto the mundane violence of this one element, the blunt inhumanity of it, and I have had to speak of it ever since. We are right to inspect it, speak of it, to try and delineate and limit this one element so that we may write something else, by writing the lives that are ours.

The cocktails you mentioned in your second letter, that I drink everyday at 5 pm (or near enough), and the ten laps I swim every day at 3:30 pm (or near enough), and the piece of old Dutch cheese that I eat with dark grained bread every morning at 10 am (or near enough) are all part of the gradual process of reclaiming my body as my own, finding myself and my safety there. My knowledge of truth and of the life I live was repudiated, and I was asked to accept and live a story that is strange and horrifying to me: to live it in my body. I've literally had to strategise the reclaiming of my body as home to the life I know myself to be living.

I had been protected from this degree of violence by my good fortune, my economic privilege, and the white, male body I was born into. Such a body is generally not up for grabs. And always I had my productivity, my product and profitable relations, to offer. I could toss them into the ever-opened maw of the market, and live comfortably. I even had a house, and could offer it to others as

a site of friendship. Many people are born into bodies stripped of this privilege, as you know and have shown me in myriad ways. To be born poor, or paperless, or black in America or female in Afghanistan (the list is as endless as the list of nations and cultures) can rob you of the body's sanctuary, simply as a condition of living.

So, what does this have to do with the privilege we are enjoying now, the chance to write letters for pay, for colleagues we admire, in a project we have high hopes for? What kind of spoiled jerk would connect the inconvenience of a deadline to the suffering of homeless and impoverished people? Any comparison between the two is absurd, and I'm not suggesting it. I'm acknowledging, though, that the choices and exchanges we make in work are part of the same general metabolism that devours human life. Your apt image was "capital as universal hormone". Our negotiations with capital are where our choices feed this metabolism, or not, or both. We're not tainted, like Nike paying children starvation wages to die sewing sneakers; we're just complicit. We live on the fat of this metabolism, and if our intelligence or our ethics are going to have any articulation in the lives of people around us, it will happen by us staying awake to the fact that this "one element" which dehumanises and abuses the dispossessed is the same one element we find digesting our lives into "a living". You write in an old stone farmhouse beneath the crop-sprayers of big agriculture. I can be imprisoned if I publish the wrong thing. Our choices as writers are never in a world apart; but that is another fact you taught me long ago.

I don't know how much of this story I've told you. In the months before I showed up as a stranger, my friend Dennis and I decided to build a table for some homeless dudes who lived in the park by my house. My reasons were self-serving. They were my neighbours (like a lot of homeless people, these four or five men, and two women, actually had a stable home (our park), yet the police claimed the right to arrest them in their home without cause) but I didn't want them in my hair. Their lives were too crazy for me. I liked them well enough and thought life would be easier without the daily spectacle of their random arrest or the impossible, and uncalled for, challenge of trying to change the way they lived. So, we built a sturdy picnic table, cleared out an ample margin of our backyard, facing the park, and put up a sign saying anyone was welcome to use it. The sign also requested civility and a generous spirit of sharing, but we had no intention to (nor did we ever) monitor it nor organise the life there.

Since the table was mine, anyone sitting there could do whatever you'd normally, legally do at home. Which meant the homeless dudes could drink, sleep, read, picnic, play cards – all the stuff that landed them in jail when they did it in the park. As with any other home, if they brawled, shot-up, sold drugs or got too rowdy, the cops could come arrest them, or tell them to stop. I'd get in trouble: my house would go on the cops' radar as a crime site and I ran the risk of appearing complicit in crimes I had no intention of policing. But, like I say, I felt I knew these guys, and I trusted them.

The trust turned out to be well placed. Those at the table were better behaved than most of my property-owning neighbours. They were happy to have rights, and every minute of every day they acted that way. They'd get drunk and play cards and raise their tall-boys of horrible malt liquors to the frustrated cops who made a point of cruising slowly past the table every day, often pulling over to harass their old antagonists. I used to romanticise cops and criminals, seduced by Genet's gorgeous prose, and thought Officer Garrison probably missed the intimacy of arresting Scotty and wrestling his heavy, drunk, one-legged body into jail every week or so. Maybe he did; but I don't romanticise cops anymore. Officer Garrison's real frustration was Scotty's vitality, his joy. The poor and dispossessed are required to be miserable. Humanity is their crime – which is why their bodies are an offense – and now the cops had to witness the joy in their bodies every day without the power to throw what offended them in jail.

Scotty, especially, rubbed it in their faces. On Google Maps, you can see him sleeping on top of the table (go to 1420 North Emerson Street, Portland, OR, 97217, "street views", and look to your right), which he liked to do partly so his autonomous pleasure would bother Officer Garrison. He'd pretend to be asleep, and Garrison's frustrated shouts were answered only with silence and smug satisfaction. It's complicated, and not entirely healthy, and I was glad it was out of my hands. Scotty and his friends planted a little garden in the dirt by the table. They filled a box with dumpster-dive foods so anyone at the table could get some. They stocked a shelf with paperback sci-fi and detective fiction. I joined in that, too, donating some books I liked.

Was this an act of "radical hospitality"? If it was, it helped enormously that none of us brought the rhetoric and quickened metabolism that comes along with that swiftly circulating coin. It helped that I didn't play host so much as I created the material circumstance in which others could host or be guests. I guess it was a "site" of radical hospitality, rather than an act of one. As an act – and especially as the conscious act of an artist quickened by the ideas gathered behind this rhetoric – the lives we are living are more swiftly subsumed by the professionalisation and canon-building that seems to follow every brilliant artistic act like a lawyer trailing ambulances. Site or act, things ended badly, and I don't have that home anymore.

To build a site enables human relations apart from the peculiar logic of the self or the fun-house mirror of art practice (or police work, or community activism, or whichever profession we cultivate to give shape and meaning to our actions) offers to the self. I like making a site, putting it somewhere, and getting out of the way. It's partly a Shostakovichian skittishness, keeping my body out of the cross-hairs. But it's also a hunch about possible stances in relation to the devouring one element. Maybe the point is to generally go slower.

I think my professional prose is mostly a site and not an act. I fuss over its design, its shape, its internal circulation, its entrances and exits. I place it in the world and let people have their way with it. I suppress or obscure my concern about its effects. It's functionality as an act in the world does not matter to me

so much as its integrity as a site. I love to encounter a generous, easy host, but I am not one. I'm not fearful so much as I'm formal. I impose form between myself and the guests, both as manners, politeness, "formalities", and in my focus on site. This is true, both at home, in my life, and in my writing.

Regarding Mmghgdgd: I remember when I started signing emails that way. It followed after I let my signature also become an indecipherable idiosyncratic scrawl. The initial feeling was one of giddy power. A signature has legal standing, and yet no one can dictate your "correct" signature. It is a rare thing – a site of legal agency granted to anyone who can move a pen. I delighted in exercising my agency, experiencing it fully every time I filled the legal requirement of "my signature" with the automatic writing of the moment. Then I found the same impulse emerging as I finished emails. My name is a gesture, more so than a name. It's typing "M" followed by a crashing dance of the fingers across the middle of the keyboard. I'm always amazed to see how much consistency there is in the result.

A strange pleasure! But yes, the reason was simply that: It made me smile. However, our exchange has shown me it was also something else. Like Shostakovich's confusing performance of a public self, it was a refusal to establish a clear, actionable self.

Your comparison to OSA is apt. Absenting my "real name" allowed me some liberty that my identity precluded. I'd like to be as nimble and graceful (and gorgeous) as OSA, but I have never managed to use it that way. This is, nevertheless, an urgent-seeming strategy. Yes, we need to offer a clear identity as safe harbour for the friendships that rely on us. But we are also in the "one element," and are obliged to conduct a kind of scrambling to "make a living" without depleting our lives (that safe harbour we provide for friendship).

I was not surprised to see your first letter, satisfying our generous commissioners' needs, came from OSA, addressed to Mmmtttjbw. And I am moved that our pursuit of the correspondence has gradually drawn us from that scrambled space toward the core of our friendship, arriving in the stable harbours we offer each other, the lives we fiercely protect and live, so that friendship can live. For that I thank you, and I thank the generous commissioners of our work.

Love, Matthew

Dear Matthew,

I think we need both sites and acts. I love Arendt's idea of the act as a political beginning – that's what I hope at best for my published words – that they might mark or annotate or point towards possible beginnings. The words – yours, mine, all the texts we love – move in the wild space between subjectivities, changing us both, old friend. Words host us.

Love,
Lisa

Lisa Robertson (b.1961) is a Canadian poet and essayist living in rural France.
Matthew Stadler (b.1959) is an American literary editor and writer living in Rotterdam.

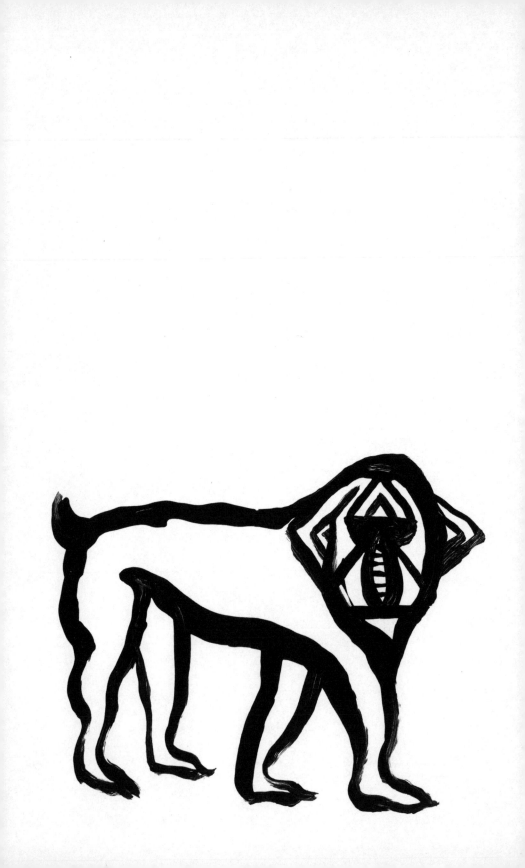

"A Monster Was Born" Notes on the Rebirth of the "Corrupt Intellectual"

Hassan Khan

In the late 19th century, a monster was born. This monster did not know what it was exactly. It knew that it needed to articulate, describe, prescribe and communicate. It knew it was supposed to play a public role in the birth of a new historical order. It knew it had a precise function in the articulation of power within the transforming social order. This monster was a speculator of knowledge, a peddler of identities, a fantasist, a cunning operator, an extrovert with a bloated ego, a necessary structural regulator.

Almost a century and a half later, I now call the direct descendant of this figure the "corrupt intellectual". It is not a very accurate term. However, I like it because it is polemical, because it describes and judges at the same time. After first using the term while speaking on a panel at Art Dubai, in 2010 I wrote an essay titled "In Defense of the Corrupt Intellectual" [1] in which I wrongly assumed that this figure was almost dead, and I saw value in resuscitating it as a counter-weight to the forces of a market that consciously presents itself as ahistorical, a cycle of circulation where the spectacular becomes both currency and function. The defense I mounted was grounded in a loose analysis of Egyptian intellectual history and was an attempt at understanding the role and meaning of that figure in the formation of a social order. I now, due to the events of the past three years, clearly recognise that I was wrong to defend this figure. This essay is an attempt to rewrite a position without completely disavowing it. I still lean strongly on my previous analysis, although with the new recognition that calcified power structures are not as easily dismantled as I first imagined. This essay looks at the role of this figure in cementing, reaffirming and producing a regime of power and subjugation. It attempts to provide some historical context, as well as to analyse the tools and methods of those I label as "corrupt intellectuals". My intention in this essay is not to condemn this figure (although they are to be damned), but rather to chart out the stormy territories we are forced to navigate on a daily basis that is our present reality. Needless to say, this moment of transformation involves a committed attempt to comprehend the complex and dangerous present as well as to sincerely propose possibilities.

The appearance of this figure is deeply entwined with the emergence of what is known as "the modern Egyptian state", which most historians agree was formed over the long forty-three years (1805–1848) of Khedive Muhammad Ali's rule over Egypt. The years under Ali's reign saw a concerted effort at creating a bureaucracy that organised and managed what it perceived as assets more efficiently. What implicitly marked that state as "modern" was in fact a side-effect of the creation of its bureaucracy: a relationship between the

population and its administration became more intimate and intrusive,
and with time it became impossible to distinguish the border between them.
The process of constructing this new relationship demanded a new discursive
order that would help explain and locate the subject and the regime. [2] In the
second half of the 19th century, with the weakening of the Alawiyya dynasty
and the increasingly complex character of the state under British occupation
(and then protection), the state apparatus began focusing on the production
of a new asset: "Egyptian identity".

The story of how this asset was managed, regulated, sold and bought
over the following century is a tragic and complex one that I will not delve
into here. However, it might be useful to roughly sketch out the present
iteration of this construction, and the mechanisms through which this insidious
strain operates, as it is indicative of a wider cultural malaise. Less specific and
more dangerous than a local corruption, it contains something endemic to the
idea of systems themselves.

In the period between the massive uprising of 1919 and the 1952 coup,
the Egyptian state held a tense relationship with a segment of its subjects. An
outpouring of public discourse, the spread of diverse political ideas (Islamism
as a political alternative, nationalism with its fascist and socialist connotations,
various strands of Marxism), as well as constant demonstrations and upheavals
marked this turbulent period. The rise of an educated cadre of functionaries
working within the state (and sometimes in opposition to its hierarchy)
necessitated a new framework that would regulate the relationship between that
cadre of bureaucrats and functionaries and the institutions and organisations
they functioned within. [3] Polemical disputes around the definitions of the nation
and the people were fought out on the pages of magazines, inside cafes and
in published treatises. In this charged atmosphere, power was denoted by
the ability to impose a definition of the terms, but it is interesting to note that
the terms themselves were not questioned. All players accepted and operated
on the same playing field. Therefore, the system of power and its opposition
were in conflict not over what the possibilities of a society could be as much
as who was to control the definition of the nation itself. [4]

The "corrupt intellectual" refers to those functionaries, poets and novelists,
museum directors and artists who claimed to speak Egypt, those who have laid
public discourse, established rules, coined terms and justified the nature of
things. Under their careful guidance a social order was constructed. However,
another order exists, seemingly invisible yet highly flexible and adaptable.
It is this indefinable, unspoken order, which tensely shares the shared social
space with official constructions, that interests me. [5]

What makes a discourse official in centralised systems is that it is structured
upon one dominant foundational referent that categorises what is valuable
and what is not – regardless of its nature – and that effectively produces a fixed
horizon of possible meanings that can only function within set parameters. In
actual fact, even if the subject officially pronounces an allegiance to this official
discourse, their actions, decisions and daily routines stand in stark opposition to

the very tenets of the discursive order. It may be that this paradox characterises all social orders, but it is more marked and visible in places where a popular culture is strident, loud and hysterical.[6] The rupture and the reconstruction that Egypt has experienced over the past three years can be understood as emerging exactly from this gap between a discursive and a lived order.

To further elucidate how these mechanisms actually develop and operate, it is necessary to consider the particularities of what I call 'the crowd'. The term is meant to be seen as the prime unit within a social order that balances the presence of the individual with that of the collective. In my previous essay, I defined the term in this way: "The crowd is where a seething mass with a unified understanding of its own presence is born, a conglomeration of frictions and tensions that manages to resolve itself into an identifiable entity." The "crowd" is a unified entity that is a site of conflict as well as resolution. It possesses self-consciousness and the ability to identify itself as a unit. This "crowd" is dense rather than simple, as its complex nature does not make it reducible to an image one can possess. Although it is a manifestation of the collective, it is not the representation of the collective, and is therefore more metonym than metaphor, i.e. it is part of the collective and not merely something that stands for it.[7] The corrupt intellectual, through writings, statements and propositions, continuously strives to simplify, possess and represent the crowd, insistently attempting to treat it as a metaphor rather than a metonym. However, the crowd's inherent complexity and density remain necessary for the construction of a regime of power. The shape of the argument, the terms of the rhetoric and the elements of the metaphor need to be grounded in real experience in order to function effectively as a tool of power. To give itself a shot at history and to produce the necessary mystifications, the regime must rely upon what is "real" (i.e. historical and material conditions) at its core. Most insidiously it manages to achieve this by denying the very complexity that it instrumentalises.

It is the nature of this "density" to actually appear in some visible form on the surface of the "crowd". "Density" has a series of different registers: First, there are the various discursive regimes under which the crowd has historically lived and "the imprint" they leave on that crowd. This means that the crowd is historical and possesses an intuitive understanding of what surrounds it – an intuition that is not metaphysical but formed through the accumulation of lived experience over centuries. Paradoxically, this sediment of experience and historicity is precisely what ahistorical discourses need in order to refer to a constructed and eternally unchanging past that transforms into the future.[8]

The second property of the crowd is its detailed intensity, produced from the individual gestures of each single individual in the crowd and their personal history. This intensity communicates both the collective gesture and isolated intentions. Since it arises from the individual, it is also an expression of selfish desire and need. In that sense, the collective is the sum total of each individual in relation to each other, and individual desires and collective identification are always in a polyphonic tension, sharing space and contradicting each other.

Furthermore, since the collective is ruled by desires and intentions, it is not blind and is capable of the self-consciousness, confidence and willpower necessary to assert its selfish demands. As such, the crowd is equally able to generate powerful, creative and even sublime mass resistance as it is able to lead to xenophobia, mass lynching and the schizoid neurosis of simultaneous self-aggrandisement and subjugation.

Finally, for the crowd to come into being, there has to be a state of consensus between each of these individuals. This density operates in two distinct fashions: On one hand, it relies on a "discursive article of faith" – which is the sedimentation of the legacies of (failed) discourses (a mix of modern dreams and old superstitions, all of which have both opposed and legitimised the status quo). The discursive article of faith gives the crowd an identity. On the other hand it is also the actual direct sociopolitical practice of these ideologies as forms of behaviour that are often contradictory to the actual article of faith. In other words, we have a crowd that is a sort of battery of potential (*The Ammunition of the Nation*) yet its very characteristics are what allows it to be subjugated in the first place. And it is that contradiction, that delicate discursive operation, which the "corrupt intellectual" has identified and become adept at managing with deadly skill.

In a sense, I am trying to point to the very basis of a daily experience of exclusion, definition and self-regulation that latently operates in all discursive orders, based upon the contradictions of identity and crowd formation. To produce that discourse and to place it in the public arena, a language that resonates with the public must be used. Therefore, a space and a context is made available for the pronouncements of functionaries, for the opinions of journalists, for the banalities of official songsmiths, to all acquire meaning. This a public space but it is not the space of the "public intellectual" who might be critical or raise pertinent questions, but rather of the ideologue whose pronouncements are essential for the transformation of the present into history. What I mean is that these pronouncements are aware of the crowd's specificities and know how to address it effectively. As a result, they can describe what we all share (our public space) by arguing for a specific idea of what is happening.

If Egypt in 2011 experienced a moment of real rupture, it must have also been an attempt to disconnect from this system of discursive orders. So far, however, it is truly and bitterly ironic that this act of rupture has in fact managed to rejuvenate these forms of narrativising. Forms that had a mere three years earlier become hollowed out and vacant have today regained significance. Why did this happen? I suspect there are reasons that reach beyond the usual answers (lack of education, lack of a political cadre, lack of collective experience). It is the public space constructed by those "corrupt intellectuals" (those demagogues, those ignorant theorisers of mediocrity, those self-satisfied complicit servants of power) that has maintained and safe-guarded a system of power after it has been shaken. They have reconstituted their discursive order by propagating a language of "stability" with terms like the *venerated patriarch*, the *honoured institution*, or *Egypt Eternal*. Although "the people" continues to be an essential phrase in

these formulations, it is only to bestow them with empty honorifics and to address them as passive subjects.

It is possible to read the "rupture" in 2011 not as an event that occurred, but rather as a sort of manifestation or sublimation of an existing condition. As previously described, a social order that is messily divided between a practiced daily routine and an out-of-touch discursive regimen will reach a point where it can only represent itself in a form of mass action. At that moment, significant actions can indeed come to embody meaning, but what they embody is not a symbol of something that exists in society; it is rather an idea of what that potentially could be.[9] The gap between the rules and regulations produced by public discourse, and the actual implementation of these regulations in daily life is exactly the space that is both full of promise as well as the place where the renewal and reconstruction of a dominant order takes place.

The corrupt intellectual is aware of this gap and thus deals in the market of phantasmatic ideas. They inhabit a world of agreements, between the intellectuals and themselves (for what role they should play) and between the different competing fantasies of what things represent or *stand* for. As well as the "master" set of agreements that make a social order possible in the first place. Official discourse backed by, and expressing, existing power structures acquires its significance through an implicit violence wrought on the total discursive field. It demands, orders, and fixes what surrounds it. A moment of rupture is the search for a new agreement. It is the demand for an agreement that would be more congruent with the structural changes that are taking place economically, socially and culturally. In contrast what happened in Egypt in 2011 is a prime example of an act of communication between subjects that accrues its power and exerts its transformative violence through its openness and lack of fixity. It therefore acts as an oppositional correlative (latent and awaiting fulfillment) to the unsublimated agreements that order and categorise our definitions. What that means is that at the basis of both acts – that of subjugation and that of revolution – is a coming to terms with an unspoken yet essential component of historical experience. My argument is that our historical experience is constituted by a morphology of the agreements that order our social experience. The difference between both poles is that subjugation fulfills the desire for the sublimation of agreements on the level of phantasm, while communication attempts to fulfill that same desire on the plane of the "real". Phantasm is always more comfortable, as the symbolic world it constructs is distant and disengaged with the actual desires of each individual. The real is dangerous and conflicted, it is where desire has not discovered a symbolic language with which to represent itself and can therefore become unsettling and potentially transformational. Yet again, it is those double-faced sycophants, those slaves of order, those vampires of dreams, who manage to confuse these two opposing acts. Their role is to publicly express subjugation as an act of popular communication.

However, right next to every such pronouncement is an apparition of hope. We should never forget that there are at least two modes operating here:

A parallel "social reality" that manages to exist under the tightest conditions, and the fact that that reality's appearance can shake the very foundations upon which the discursive regime is organised. In this parallel world, potentialities that can never be achieved under the existing discursive regime of power are possible and unconscious *and* exist in real time. And it is exactly because it is not labeled or celebrated that makes this parallel world so pertinent and powerful. We should not over-romanticise it and recognise that although this is a space of great potential, it is an amoral space that doesn't care about the well-being of the individual, but that strives to find a moment of correlation between the productions of the collective (with their latencies: whether the horror of collective hysteria, fear and paranoia or the incredible power of the autonomous anonymous formal articulation of unknown realities) and the superstructure they live under. [10] What I am attempting to describe is not the power of the collective, as much as the very material ability of a condition to exist that surpasses the dynamics that attempt to produce and order it.

What interests me here is some sort of formalism rather than an expressionistic celebration of subjectivity. This is the space where collectively produced culture takes its material and sources from the existing structure and manages to produce forms that do not go beyond the narrow confines of a strategic maneuver within the field of their production, i.e. they are designed to fulfill their roles as entertainment, or as jokes, or as wedding songs, or as markers of territory. Yet at the same time, these forms almost unintentionally manage to escape the horizon of their functionality and take on an accidental formalism, in the form of songs, sayings, magic spells or bodily gestures. These secret moments of formalism exist across all sectors in society and are not only the domain of the popular classes. [11] However, we are now at a moment where the narrative of class fulfillment itself has been shaken. The revolution did not shake it, but the revolution came as a development out of the narrative's actual collapse.

However, I still believe in the absolute significance of what happened in January 2011. It is almost a tribute to the power of that moment that the reconstitution of the dominant order is so extreme. The popular imaginary has been disturbed and longs for the calm stagnant stability of the known. The revolution has therefore succeeded.

As such, any sort of politics invested in transformation and taking rupture as its starting point will have to take into account the resonance produced by making a statement within closed horizon of meaning that has been determined by the functionaries of the dominant order. This is not to support their statements but to realise that their historical density is constitutive of the idea of meaning itself, at least in our present context. To attempt to step out of that, to practice rupture, would be to recognise it for what it is: to abandon claims of "liberation", transcendent doxas of "progress", to abandon the "people", to abandon "hope", to abandon the "dream", to abandon "possibility" – all in the name of a transformation itself.

1 The first version of this text appeared in *How to Begin? Envisioning the Impact of Guggenheim Abu Dhabi*, a thesis project edited by Özge Ersoy at the Center for Curatorial Studies, Bard College. A second version appeared in issue #18 of *e-flux* journal in September 2010.

2 Under Muhammad Ali this production of discourse was driven by an expansionist ambition as well as the need to establish a dynasty.

3 The deeply orientalist views institutionalised within the educational and cultural system and initiated by the presence of mainly foreign "experts" who held the highest positions within the Egyptian bureaucracy in the first half of the 20th century introduced another element to this system of definitions. Therefore what we had was a three-way argument around the nature of the state and its peoples.

4 In the future, this was to have dire consequences, namely to evacuate the very idea of national liberation and independence of any potential it might have had.

5 In the systems of power I am attempting to engage here, the regime and its opposition are closer to each other than they imagine as they share a deep investment in strengthening an allegiance to a national identity regardless of what that identity is supposed to be.

6 Important to note that this texture, this loud, strident hysteria, is not some sort of innate quality of the "people" but rather a very sophisticated transmutation of the material conditions those same people live under.

7 This seemingly minor difference in linguistics is actually highly significant and is the trademark of the discursive order that the corrupt intellectual produces – in service of the regime of power that it deliberately produces this confusion for.

8 Witness the rhetorical arguments that disingenuously portray injustice and subjugation as the eternal lot of the people, the argument gains credibility by referring to an experience that is innately known to be true, yet it is disingenuous because it portrays it as a static unchanging condition, while it is actually a highly nuanced, continuously transmutating condition that has been met with (conveniently forgotten) unwavering resistance.

9 However this is not the simple binary gap between ideals believed in and strived for and the reality of daily life, and it's not merely a simple moral hypocrisy. It's rather a structural property of the social reality that exists in a shared space we can call Egypt.

10 In a sense this is the opposite of the dynamics of reification and alienation, the domain of the phantasm. I know that we come dangerously close to populism here, proposing some kind of naïve belief in the power of the collective to produce real experiences.

11 But it might be that the popular classes are the least invested in the dominant narrative (as it ultimately serves them the least) while the middle classes are instrumental in forging this narrative and the wealthy classes directly benefit from it.

Hassan Khan (b.1975) is an Egyptian artist, musician and writer living in Cairo.

Representations of an Intellectual: Professionals and Amateurs

Edward Said

Some years ago the versatile and ingenious French intellectual Regis Debray wrote a penetrating account of French cultural life entitled *Teachers, Writers, Celebrities: The Intellectuals of Modern France*. Debray himself had once been a seriously committed left-wing activist who had taught at the University of Havana shortly after the Cuban Revolution of 1958; some years later, he was given a 30-year prison term by the Bolivian authorities because of his association with Che Guevara. Yet he only served three years of his sentence and after his return to France, Debray became a semi-academic political analyst and, later still, an adviser to President Mitterrand. Debray's thesis in his book is that between 1880 and 1930 Parisian intellectuals were principally connected to the Sorbonne; they were secular refugees from both church and Bonapartism, where in laboratories, libraries and classrooms the intellectual, protected as a professor, could make important advances in knowledge.

After 1930, the Sorbonne slowly lost its authority to new publishing houses like the Nouvelle Revue Francaise, where, according to Debray, "the spiritual family", comprising the intelligentsia and their editors, was given a more hospitable roof over its head. Until roughly 1960, such writers as Sartre, De Beauvoir, Camus, Mauriac, Gide and Malraux were in effect the intelligentsia who had superseded the professoriate, superseded them because of their free-ranging work, their credo of freedom and their discourse that was "midway between the ecclesiastical solemnity that went before it and the shrillness of the advertising that came after."

Around 1968, intellectuals largely deserted their publishers' fold; instead they flocked to the mass media – as journalists, talk show guests and hosts, advisers, managers and so on. Not only did they now have a huge mass audience, but also their entire life's work as intellectuals depended on their viewers, on acclaim or oblivion as given by those "others" who had become a faceless, consuming audience out there. Debray says: "By extending the reception area, the mass media have reduced the sources of intellectual legitimacy, surrounding the professional intelligentsia, the classic source of legitimacy, with wider concentric circles that are less demanding and therefore more easily won over."

What Debray describes is almost entirely a local French situation, the result of a struggle between secular, imperial and ecclesiastical forces in that society since Napoleon. It is therefore most unlikely to duplicate the picture he provides for France in other societies. In Britain, for example, the major universities before World War Two could hardly be characterised in Debray's terms, since even Oxford and Cambridge dons were not principally known in the public domain as intellectuals in the French sense; and, although British publishing

houses were powerful and influential between the two world wars, they
and their authors did not constitute the spiritual family Debray speaks about
in France. Nevertheless, the general point is a valid one: groups of individuals
are aligned with institutions and derive power and authority from those
institutions. As the institutions either rise or fall in ascendancy, so too do
their organic intellectuals who work inside them.

And yet the question remains as to whether there is or can be anything like
an independent, autonomously functioning intellectual: one who is not beholden
to, and therefore constrained by, his or her affiliations with universities that
pay salaries, political parties that demand loyalty to a party line, think-tanks
that while they offer freedom to do research, perhaps more subtly compromise
judgement and restrain the critical voice. As Debray suggests, once an intellectual
circle is widened beyond a like group of intellectuals – in other words, if instead
of depending on other intellectuals for debate and judgement and one starts
instead to worry about pleasing an audience or an employer – something in
the intellectual's vocation is, if not abrogated, then certainly inhibited.

We come back once again to the main theme of these lectures: the
representation of the intellectual. When we think of an individual intellectual –
the individual is my principal concern here – do we accentuate the individuality
of the person in drawing his or her portrait, or do we rather make our focus the
group or class of which the individual is a member. The answer to this question
obviously affects our expectations of the intellectual's address to us. Is what
we hear or read an independent view, or does it represent a government, an
organised political cause, a lobbying group? 19th century representations of the
intellectual tended to stress individuality – the fact that very often the intellectual
is, like Turgenev's Bazarov or James Joyce's Stephen Dedalus, a solitary, somehow
aloof figure who does not confirm to society at all and is consequently a rebel
completely outside established opinion. With the increased number of 20th
century men and women who belong to a general group called "intellectuals"
or the "intelligentsia" – the managers, professors, journalists, computer or
government experts, lobbyists, pundits, syndicated columnists, consultants who
are paid for their opinions – one is impelled to wonder whether the individual
intellectual as an independent voice can exist at all.

This is a tremendously important question, I think, and it must be looked
into with a combination of realism and idealism, certainly not cynicism. A
cynic, Oscar Wilde said, is someone who knows the price of everything but
the value of nothing. To accuse all intellectuals of being sellouts just because
they earn their living working in a university or for a newspaper is a coarse
and, finally, meaningless charge. Thus it would be far too indiscriminately
cynical to say that the world is so corrupt that everyone ultimately succumbs to
Mammon. On the other hand, it is scarcely less serious to hold up the individual
intellectual as a perfect ideal, a sort of shining knight who is so pure and so
noble as to deflect any suspicion of material interest. No-one can pass such a test,
not even Joyce's Dedalus, who is so pure and fiercely ideal as in the end to be
incapacitated and, worse, silent. The fact is that the intellectual ought neither

to be so uncontroversial and safe a figure as to be just a friendly technician, nor – going in the opposite direction – should the intellectual try to be a full-time Cassandra, as unpleasant in being right as she was and as unheard as well. Every human being is held in by society, no matter how free and open the society, no matter how bohemian the individual. In any case, the intellectual is supposed to be heard from, and in practice ought to be stirring up debate and, if possible, controversy. But the alternatives are not total quiescence or total rebelliousness.

During the waning days of the Reagan administration, a disaffected left-wing American intellectual called Russell Jacoby published a book that generated a great deal of discussion, much of it approving. It was called The Last Intellectuals, and argued the unimpeachable thesis that in the United States "the non-academic intellectual" had completely disappeared, leaving no one in that place except a bunch of timid and jargon-ridden university dons, to whom no one in the society paid any attention. Jacoby's model for the intellectual of yore was comprised of a few names that lived mostly in Greenwich Village (the local equivalent of the Latin Quarter) earlier this century and were known by the general name of the New York intellectuals. Most of them were Jewish, left-wing (but anti-Communist), and managed to live by their pens. Figures of the earlier generation included men and women like Edmund Wilson, Jane Jacobs, Lewis Mumford, Dwight MacDonald; their later counterparts were Philip Rahv, Alfred Kazin, Irving Howe (who died only a few weeks ago), Susan Sontag, Daniel Bell, William Barrett, Lionel Trilling. According to Jacoby the likes of such people have been diminished by various post-war social and political forces: the flight to the suburbs (Jacoby's point being that the intellectual is an urban creature); the irresponsibilities of the Beat Generation, who pioneered the idea of dropping out and fleeing from their appointed station in life; the expansion of the university; and the drift to the campus of the former American left.

The result is that today's intellectual is most likely to be a closeted literature professor, with a secure income and no interest in dealing with the world outside the classroom. Such individuals, Jacoby alleges, write an esoteric and barbaric prose that is meant mainly for academic advancement and not for social change. Meanwhile, the ascendancy of what has been called the neo-conservative movement – intellectuals who had become prominent during the Reagan period but who were in many cases former left-wing, independent intellectuals, like Irving Kristol and Sidney Hook – brought with it a whole host of new journals advancing an openly reactionary, or at least conservative, social agenda. Jacoby mentions the extreme right-wing quarterly the New Criterion in particular. These new forces, says Jacoby, were and still are much more assiduous at courting young writers, potential intellectual leaders who can take over from the older ranks. Whereas the New York Review of Books, one of the most prestigious liberal journals in America, had once pioneered daring ideas as expressed by new and radical writers, it had now acquired "a deplorable record", resembling in its ageing Anglophilia "Oxford teas rather than New York delis."

Jacoby keeps coming back to his idea of an intellectual whom he describes as an "incorrigibly independent soul answering to no one." "All that we have now", he says, "is a missing generation, which has been replaced by buttoned up, impossible to understand classroom technicians, hired by committee, anxious to please various patrons and agencies, bristling with academic credentials and a social authority that does not promote debate but establishes reputations and intimidates non-experts." This is a very gloomy picture, but is it an accurate one? Is what Jacoby says about the reason for the disappearance of intellectuals true, or can we offer in fact a more accurate diagnosis? In the first place I think it is wrong to be invidious about the university, or even about the United States. There was a brief period in France shortly after the Second World War when a handful of prominent independent intellectuals like Sartre, Camus, Aron, De Beauvoir seemed to represent the classic idea – not necessarily the reality – of intellectuals descended from their great (but alas often mythical) 19th century prototypes like Renan and Humboldt. But what Jacoby doesn't talk about is that intellectual work in the 20th century has been centrally concerned not just with public debate and elevated polemic of the sort advocated by Julien Benda, the early 20th century French man of letters, and exemplified perhaps by Bertrand Russell and a few bohemian New York intellectuals, but also with criticism and disenchantment, with exposure of false prophets and debunking of ancient traditions and hallowed names.

Besides, being an intellectual is not at all inconsistent with being an academic or a pianist, for that matter. The Canadian pianist Glenn Gould was a recording artist on contract to large corporations for the whole of his performing life: this did not prevent him from being an iconoclastic reinterpreter of and commentator on classical music with tremendous influence on the way performance is realised and judged. By the same token, academic intellectuals – historians, for example – have totally reshaped thought about the writing of history, the stability of traditions, the role of language in society. One thinks of Eric Hobsbawm and E P Thompson in England, or Hayden White in America. Their work has had wide diffusion beyond the academy, although it mostly was born and nurtured inside it.

As for the United States being especially guilty of denaturing intellectual life, one would have to dispute that since everywhere one looks today, even in France, the intellectual is no longer a bohemian or café philosopher, but has become a quite different figure representing many different kinds of concerns, making his or her representations in a seriously altered way. As I have been saying throughout these lectures, the intellectual is less a sort of statue like icon than an individual vocation, an energy, a stubborn force engaging as a committed and recognisable voice in language and in society with a whole slew of issues, all of them having to do in the end with a combination of enlightenment and emancipational freedom.

The particular threat to the intellectual today, whether in the West or the non-Western world, is not the academy, nor the suburbs, nor the appalling commercialism of journalism and publishing houses. Rather the danger comes

from an attitude that I shall be calling professionalism; that is, thinking of your work as an intellectual as something you do for a living, between the hours of nine and five with one eye on the clock, and another cocked at what is considered to be proper, professional behaviour – not rocking the boat, not straying outside the accepted paradigms or limits, making yourself marketable and above all presentable, hence uncontroversial and unpolitical and "objective".

Let us go back to Sartre for a moment. At the very time that he seems to be advocating the idea that man – no mention of woman – is free to choose his own destiny, he also says that the situation (one of Sartre's favourite words) may prevent the full exercise of such freedom. And yet, Sartre adds, it is wrong to say that milieu and situation unilaterally determine the writer or intellectual. Rather there's a constant back and forth between them. In his credo as an intellectual, published in 1947, *What is Literature?*, Sartre uses the word "writer" rather than "intellectual", but it is clear that he is speaking about the role of the intellectual in society as in the following all-male passage: "Whatever game he may want to play, the intellectual must play it on the basis of the representation which others have of him. He may want to modify the character that one attributes to the man of letters or intellectual in a given society, but in order to change it he must first slip into it. Hence the public intervenes with its customs, its vision of the world, and its conception of society and of literature within that society. It surrounds the writer, it hems him in, and its imperious or sly demands, its refusals and its flights are the given facts on whose basis a work can be constructed."

Sartre is not saying that the intellectual is a kind of withdrawn philosopher-king whom one ought to idealise and venerate as such. On the contrary – and this is something that contemporary lamenters over the disappearance of intellectuals tend to miss – the intellectual is constantly subject not only to the demands of his or her society, but also to quite substantial modifications in the status of intellectuals as members of a distinct group. In assuming that the intellectual ought to have sovereignty or a kind of unrestricted authority over moral and mental life in a society, critics of the contemporary scene simply refuse to see how much energy has been poured into resisting, even attacking authority of late. This has resulted in radical changes in the intellectual's self-representation.

Today's society still hems in and surrounds the writer, sometimes with prizes and rewards, often with denigrations or ridiculings of intellectual work altogether; still more often was saying that the true intellectual ought to be only an expert professional in his or her field. I don't recall Sartre ever saying that the intellectual should remain outside the university necessarily. He did say that the intellectual is never more an intellectual than when surrounded, cajoled, hemmed in, hectored by society to be one thing or another because only then, and on that basis, can intellectual work be constructed. When he refused the Nobel Prize in 1964, he was acting precisely according to his principles.

What are these pressures in the 1990s? And how do they fit what I have been calling professionalism? What I want to discuss are four pressures which

I believe challenge the intellectual's ingenuity and will. None of them is unique to only one society. Despite their pervasiveness, each of them can be countered by what I shall call amateurism, the desire to be moved not by profit or reward but by love for and unquenchable interest in the larger picture, in making connections across lines and barriers, in refusing to be tied down to a speciality, in caring for ideas and values despite the restrictions of a profession.

Specialisation is the first of these pressures. The higher one goes in the education system today, the more one is limited to a relatively narrow area of knowledge. Now no one can have anything against competence as such, but when it involves losing sight of anything outside one's immediate field – say early Victorian love poetry – and the sacrifice of one's general culture to a set of authorities and canonical ideas, then competence of that sort is not worth the price paid for it.

In the study of literature, for example, which is my particular interest, specialisation has meant an increasing technical formalism, and less and less of a historical sense of what real experiences actually went into the making of a work of literature. Specialisation loses you sight of the raw effort of constructing either art or knowledge; as a result you cannot view knowledge and art as choices and decisions, commitments and alignments, rather than impersonal theories or methodologies. To be a specialist in literature too often also means shutting out history, or music, or politics. In the end, as a fully specialised literary expert, you become tame and accepting of whatever the so-called leaders in the field will allow. Specialisation also kills your sense of excitement and discovery, both of which are irreducibly present in the intellectual's makeup. In the final analysis, giving up to specialisation is, I have always felt, laziness: doing what others tell you is always done because that is your speciality, after all.

If specialisation is a kind of general instrumental pressure present in all systems of education everywhere, expertise and the cult of the certified expert are more particular pressures in the post-war world. To be an expert you have to be certified by the proper authorities; they instruct you in speaking the right language, citing the right authorities, holding down the right territory. This is especially true when sensitive and/or profitable areas of knowledge are at stake. There has been a great deal of discussion recently of something called "political correctness", an insidious phrase applied to academic humanists who, it is frequently said, do not really think independently but rather according to norms established by a cabal of leftists; these norms are supposed to be overly sensitive to racism, sexism and the like, instead of allowing people to debate in what is supposed to be an "open" manner.

The truth is that the campaign against political correctness has been conducted by various conservatives and other champions of family values. Although some of the things they say have some merit – especially when they pick up on the sheer mindlessness of unthinking cant – their campaign totally overlooks the amazing conformity and political correctness where, for example, military, national security, foreign and economic policy have been concerned. During the immediate post-war years, for example, so far as the Soviet Union

was concerned you were required to accept unquestioningly the premises of the Cold War, the total evil of the Soviet Union, and so on and so forth. For an even longer period of time, roughly from the mid-1940s until the mid-1970s, the official American idea held that freedom in the Third World meant simply freedom from Communism: it reigned virtually unchallenged; and with it went the notion – endlessly elaborated by legions of sociologists, anthropologists, political scientists and economists – that "development" was non-ideological, derived from the West and involved economic take-off, modernisation, anti-Communism and a devotion among some political leaders to formal alliances with the United States.

For the United States and some of its Western associates, like Britain and France, these views about defence and security often became dogma. This resulted in imperial policies, in which counter-insurgency and an implacable opposition to native nationalism (always seen as tending towards Communism and the Soviet Union) brought immense disasters in the form of costly wars (such as the one in Vietnam), indirect support for invasions and massacres (like those undertaken by allies of the West, such as Indonesia, El Salvador and Israel) and client regimes with grotesquely distorted economies. To disagree with all this meant, in effect, interfering with a controlled market for expertise tailored to further the national effort.

For "expertise" in the end has rather little, strictly speaking, to do with knowledge. Some of the material brought to bear on the Vietnamese war by Noam Chomsky is far greater in scope and accuracy than similar writing by certified experts. But whereas Chomsky moved beyond the ritually patriotic notions – that included the idea that "we" were coming to the aid of our allies, or that "we" were defending freedom against a Moscow – or Peking-inspired takeover – and took on the real motives that governed US behaviour, the certified experts, who wanted to be asked back to consult or speak at the State Department or work for the Rand Corporation, which was a research company originally established by the Department of Defense, they never strayed into that territory at all. Chomsky has told the story of how when as a linguist he has been invited by mathematicians to speak about his theories, then he is usually met with respectful interest, despite his relative ignorance of mathematical lingo. Yet when he tries to represent US foreign policy from an adversarial standpoint the recognised experts on foreign policy try to prevent his speaking, on the basis of his lack of certification as a foreign policy expert. There is little refutation offered as arguments; just the statement that he stands outside acceptable debate or consensus. The third pressure of professionalism is the inevitable drift towards power and authority in its adherents, towards the requirements and prerogatives of power, towards being directly employed by it. In the United States, the extent to how much the agenda of the national security mentality set priorities in academic research during the period when the US was competing with the Soviet Union for world hegemony is quite staggering. A similar situation obtained in the Soviet Union, but in the West no one had any illusions about free inquiry there. We are only just beginning to wake up

to what it meant that the American Departments of State and Defense provided the largest amount of money of any single donor for university research in science and technology.

But it was also the case that during the same period university social science and even humanities departments were funded by the government for the same general agenda. Something like this occurs in all societies, of course, but it was noteworthy in the US, however, because in the case of some of the anti-guerrilla research carried out in support of policy in the Third World – South-East Asia, Latin America and the Middle East principal among them – the research was applied directly in covert activities, sabotage and even outright war.

Nor has this been all. Centralising powers in American civil society, such as the Republican or Democratic parties, industry or special interest lobbies like those created or maintained by the gun-manufacturing, oil, and tobacco corporations, large foundations like those established by the Rockefellers, the Fords or the Mellons, all employ academic experts to carry out research and study programmes that further commercial as well as political agendas. This, of course, is part of what is considered normal behaviour in a free market, and occurs throughout Europe and the Far East as well. There are grants and fellowships to be had from think-tanks, plus sabbatical leaves and publishing subventions, as well as professional advancement and recognition.

Everything about the system is above board and, as I have said, is acceptable according to the standards of competition and market response that govern behaviour under advanced capitalism in a liberal and democratic society. But in spending a lot of time worrying about the restrictions on thought and intellectual freedom under totalitarian systems of government, we have not been as fastidious in considering the threats to the individual intellectual of a system that rewards intellectual conformity, as well as willing participation in goals that have been set not by science but by the government; accordingly, research and accreditation are controlled in order to get and keep a larger share of the market.

In other words, the space for individual and subjective intellectual representation, for asking questions and challenging the wisdom of a war or an immense social programme that awards contracts and endows prizes, has shrunk dramatically from what it was a hundred years ago, when Stephen Dedalus could say that as an intellectual his duty was not to serve power at all. Now I do not want to suggest as some have – rather sentimentally, I think – that we should recover a time when universities were not so big, and the opportunities they now offer were not so lavish. To my mind the Western university still offers the intellectual a quasi-utopian space in which reflection and research can go on, albeit under new constraints and pressures.

Therefore, the problem for the intellectual is to try to deal with the impingements of modern professionalisation as I have been discussing them, not by pretending that they are not there or denying their influence, but by representing a different set of values and prerogatives. These I shall collect under the name of amateurism, literally, an activity that is fuelled by care and affection rather than by profit, and selfish, narrow specialisation.

An amateur is what today the intellectual ought to be, someone who considers that to be a thinking and concerned member of a society one is entitled to raise moral issues at the heart of even the most technical and professionalised activity as it involve one's country, its power, its mode of interacting with its citizens as well as with other societies. In addition, the intellectual's spirit as an amateur can enter and transform the merely professional routine most of us go through into something much more lively and radical; instead of doing what one is supposed to do one can ask why one does it, who benefits from it, how can it reconnect with a personal project and original thought.

Every intellectual has an audience and a constituency. The issue is whether that audience is there to be satisfied, and hence a client to be kept happy, or whether it is there to be challenged, and hence stirred into outright opposition, or mobilised into greater democratic participation in the society. But in either case, there is no getting around authority and power, and no getting around the intellectual's relationship to them. How does the intellectual address authority: as a professional supplicant, or as its unrewarded, amateurish conscience?

This is a transcript of Edward Said's fourth Reith Lecture broadcast on 2 August 1993 on BBC Radio 4.

Edward Said (1935–2003) was a Palestinian-born American literary theorist.

You Play Every Time You Rehearse

Mai Abu ElDahab

These are notes I could have written a year ago at the start of this adventure, but are written now with the advantage of some hindsight. In a way, they are like a letter written to myself, with a deliberate address that mimics the privileged openness typical of conversation between friends. To make some sense of what follows, it is to be taken as a spring cleaning of ideas and a making room for new ones to trickle in, a kind of self-revisionism linking past and present, with an eye on a future.

Here goes …

I. Why It's Preferable to Speak in Your Own Words

James Whistler argued with everyone. Towards the end of his life, the only friend he had left (nearly) was French poet Stéphane Mallarmé, reportedly not the nicest person himself. I'm a novice in the study of Whistler, but as a curious enthusiast I've been trying to understand the complexity of this rogue character. Whistler notoriously sued the art critic John Ruskin for writing a negative review of his work. The trial's outcome was unsatisfactory to both parties, but remains hearty food for thought. It's important to note that Whistler was already very well-known in art circles and even among a broader literate public, so the controversy he sparked wasn't the simple self-promotional stunt his detractors suggest.

I presume Whistler chose to pursue his day in court not necessarily just to win. While he did orchestrate an opportunity to stand up and perform before an audience, the more significant motive (and outcome) was that of having his defence of art noted, signed, sealed, and delivered for posterity. No doubt he was an exceptional painter and many an art historian will vouch for his contribution to the canon. But he was also a thinker and a dilettante advocate whose aggressively vocal approach forced a debate that required each actor to take responsibility for the position they espoused. By virtue of taking a public stance, Whistler (if symbolically) pushed a button that thrust artistic debates out from the privacy of the bourgeois salon and anchored them in the sphere of public concern. It's not the substance of his arguments that laid this ground – for one, he was adamantly against a social function for art – rather that his position demanded responsibility and accountability, even if it meant losing a popularity contest.

Zoom forward to present day, when in very different circumstances it seems crucial to revive Whistler, not the painter but the spirit. An art world

stuck between the inherent contradictions of relying on public-private financing while grappling with a thoroughly battered definition of social value begs for reinvention. A long hard battle fought by artists for over a century to infiltrate every domain of public life and make it their own is being diminished to the sheltered territory of embellishment for the affluent class, or alternatively being swallowed up by the stringent bureaucracies of the new art academia.

By definition, an art entangled with intellectual endeavour cannot be position-less or ethic-less, and so inevitably stands or strives for something. It is this positioning that speaks for more than idiosyncrasy and distinguishes the thoughtful from the decorative. Once art stepped into an affective relationship with life, it carved out a space for itself within the broader work of cultural questioning and social critique, and these are the parameters that today define the contemporary art field, making it an exciting place to be in, albeit only when that relationship is functioning. Otherwise, the work devolves into a mélange of aesthetics and administration.

A reconsideration of Whistler's recalcitrance stands for revisiting and revising these questions — a timely call to insist positions be assumed with gentleness, ferocity, humour, or even earnestness, but always be publicly pronounced. Else there is no conversation to be had.

II. When Bureaucrats Ruled the Earth

In a structure built on authority and hierarchy, it is impossible to ask principled questions because that structure's very existence is predicated on devising protocols that circumvent any contestation of its existence. Growth is then considered the indicator of an institution's success. If an institution's mandate is power, then success is tantamount to expanding its area of activity and scope of influence. Protocol is the new assembly line; the how-to for packaging individuality. If you can't make handmade desirables with a machine, turn the concept of "handmade" into a genre or category (and strip it of its particularity and nuance).

Protocols are pivotal to professionalisation, defined as the enforcing of a set of rules that are purported to support, yet in fact determine, the most consistent and therefore the most efficient methods of working in a specific

field or discipline. Unfortunately, aside from marketing-driven PR machines, superbly written applications, organised schedules of meetings, and diligent conformity to deadlines, most of us who don't dabble in the art market and are not part of patron-sexy institutions have yet to reap the benefits of this so-called advancement (for example, decent compensation based on experience and skills, job descriptions, contracts designed to protect all parties, paid leave, etc.).

I often encounter this suspect term (professionalisation) as a misnomer used to describe a streamlined, ten-step production process designed irrespective of the intended outcome, or an artist's careful digital archiving of a thriving three-year career, or, even more alarmingly, that preformatted event called the studio visit, where you might find yourself sitting in silence alongside an artist, watching a fast-forwarded version of their video because it's assumed you'd never otherwise make the time. Named for what it is, in the art field "professionalisation" amounts to bureaucratisation, and that's a concept very distant from the idea of what commitment to a profession in terms of its own logic and aspirations entails.

In this new, professionalised world, speaking of 'practice' is inevitable. It's no surprise the word has become *de rigeur*, since following imposed rules leads to repetition and lethargy — that heavily burdened sigh of the bureaucrat asked to do something that forces a change in their precisely constructed routine. Practically speaking, this is how attention to detail and specificity is lost to mania and easy excuses.

III. Crude Ambition

I want to be able to pay my rent. I want to eat a meal in a restaurant, buy books and a new pair of boots from time to time, and rent a small place near the sea in some Mediterranean village during summer holidays every once in a while. What I describe is a lower-middle-class life (the European version) that corresponds with my background, education and economic aspirations. Perhaps one day I would be able to take out a mortgage, or maybe not. I'm providing these explicit details, lest my assertions be left open to relativising.

My livelihood depends on available opportunities and severe choices. Many of my friends and peers live comfortably in the same boat, and aside from the occasional, more serious money struggle, they are aware that making certain choices may not be financially lucrative, but lucre is not a primary concern, once the basics are covered. This is not a question of snubbing materialism (that's irrelevant here), rather an account of what it is to live with one's focus directed elsewhere. (In any case, the goal of making a lot of money demands a lot of concentration to that end.) What we want is to be participants in, and sometime instigators of, artistic discourse – a conversation with artists, thinkers, writers, and anyone else invested first and foremost in a world of ideas.

A vast array of acknowledged and deliberated conditions contributed to the current financial squeeze, but the ease with which the cash purchase of a seat

at the cultural table is celebrated seems eerily conspiratorial. The occurrence of this buy-in is a commonplace with which we are all too familiar, and typically either ignore or partake in to varying degrees. In effect, a field that strives for knowledge and active criticality is pervaded by glamour, fetish, and prestige. Many artists, writers, and curators who thought they were seated where they belonged now find themselves at a table they never wanted to join in the first place. Hadn't they already made other choices? A new de facto tolerance in the art world for speaking on behalf of money, as if it were the game-changer, is a strange and excessive kind of imposed complicity.

iv. Where Has the Radical Future Gone?

Claude Parent is full of ideas. The first few times I met him, I thought his quiet refusal to discuss the logistics of our planned project expressed a disinterest in banality. It took me some months to realise that he was not only very aware of what the project implied in practical terms, but had deliberately danced around the subject to avoid being stifled by too much detail too soon. He harboured no malicious intent whatsoever, only a lifetime's experience including a lifetime's worth of fight, which had solidified a conviction that thinking and imagining come before possibility. It is this quality, in part, that makes Claude Parent a man to learn more about. He insists that every aspect of architecture is open to questioning. The work doesn't come down to belonging to a school, a movement, or a time but any day, we can start afresh with a blank slate.

Not so long ago, I had breakfast with a friend who told me he'd been invited to an esteemed museum to discuss making a book for an upcoming exhibition. Prompted to speak first, he had begun by expressing how pleased

he was with the potential of so much time (18 months) for conversation. By which he imagined discussion and development of a precise response to the exhibition's publishing requirements. His prospective contractor responded by informing those present that "Visitor Projection" had indicated that this (placing a dummy on the table) was what the book will look like (size, number of pages, paper stock, and so on). What we encounter at this rendezvous is the history of publishing and design reduced to an administrator's template; your and my reading (see: buying) habits identified and serviced; my friend's gifted expertise turned into a brand without need of a product; stability assured; and a conventional and popular tool for thinking demeaned.

Where do those whose desire to invent precludes prescriptions find a place to think, make, and discover their allies? For Claude Parent, a prominent yet untrained architect, the dissemination of his ideas occurs through his varied tools – he uses drawings, models, and plans to propose a world, and not to represent or scale one, tools to teach and to learn. Although he has voiced his regret over not having built more, he basks in the reassurance that his ideas continue to make their way into others' constructions, changing for some people in some instances how they live and how they experience their surroundings.

Sadly, the staff and visitors of the museum that presented my friend with an outcome – before the process of creating unforeseen possibilities could even begin – will not have the pleasure of building or seeing a world in a book.

v. Think Real Small

PechaKucha is a popular marketer's game for content sharing. It entails organising a long series of short presentations around a set number of Powerpoint slides, each of which appear for a brief, uniform period of time animated by speedy commentary. This formatted reductiveness is traumatising not only to those victimised by it, but also to those left unquenched by the clamour. Nothing really interesting can be summarised in a sound bite, press release, or a four-minute lecture. This publication celebrates an opposite approach – the slow introverted dialogue through which a thinker perseveres in the process of composing a researched, thoughtful, and creative piece of writing.

In this book are some contributions by poets. To provide an image, rather than give room for a caricature, it is fair to assume that these are people sitting in what's likely a small room somewhere, in a city, with a MacBook, typing words selected with great care. Another image, a far cry from poetics, is that of a large, open-plan office somewhere more remote, where others, also typing, are overly lax about giving words away, and distorting their meanings for the sake of accumulation. The contradiction here is stark: the silence broken by the slow imprinting of a word on a keyboard versus the energetic commotion of an office full of people who tweet their every action to beeping smartphones across the globe. Poets tweet too, but the real difference is in how each expends a tool and to what end. This is not to be misunderstood as a kind of nostalgia

but an elementary metaphor for distinguishing between narrative as a place where meaning happens as opposed to a format superseding the message.

Activity for its own sake might be a form of exercise, but it's not production. The same goes for how we use words and how that use relates to knowledge.

VI. And Then There's You

The doors to the show will open, you will walk into rooms, you will look, and eventually, you will leave. Hopefully, you will leave full of ideas. An exhibition is a tool, and an efficient one at that, but only one of many possible forums where ideas are developed and shared by artists. It's a tool that lets a specific kind of language find a way to ask questions; a tool that meshes reality and abstraction; and a tool that, under precise circumstances, is a magnet for shared enthusiasm.

Anyone who has been involved in writing a funding application is familiar with the phrase "indicators of success" – a bullet-point list of what criteria the funder and you should use to assess the outcome of your project. It's a strange formulation that's most often answered in jargon concerning visitor numbers, educational programs, accurate expenditures, quantity of productions, etc. I'm not certain that a qualitative system would be more desirable (or that quality in this sense is possible to systematise), but what I do know is that voluntarily adopting the language of funding applications for ourselves is not only tedious but damaging. To allow externally generated criteria to determine the value of an art project or initiative is lazy and a poverty of aspiration compared to the personal, often painstaking, commitment that goes into making an artwork.

How can we follow criteria when the question is always changing, not just the answer? To be alert to the changing question and to find oneself provoked to find new ways of answering, now that's a real ambition.

Endnote: In the past couple of years, I've been occupied by questions to do with my own changing working situation, but also with new conditions in the corner of the art world where I'm standing. The state of in-between I've experienced turns out to be ripe for naming specific desires and clarifying the kind of ambition that can satisfy them. What preceded was a snapshot, or maybe more of a long exposure, of my thinking from this state: a collection of fragments, anecdotes and doubts that have found their way, in this instance, into the making of a show and the forming of its relationships – some words in an ongoing conversation. The title is a misquoting of Thelonius Monk's famous adage "You Rehearse Every Time You Play".

Mai Abu ElDahab (b.1977) is an Egyptian curator living in Brussels.

Afterword: The Death of the Translator

George Szirtes

1

The translator meets himself emerging from his lover's bedroom.
So much for fidelity, he thinks.

2

Je est un autre, said the translator. Try next door.

3

The translator was looking down his own throat. Come out, come out,
wherever you are! he pleaded.
The translator's wardrobe was full of other people's shirts. At least they
fitted him.
The translator stood in front of the window pretending to be transparent.
But if everything is potentially everything else, complained the translator,
what am I doing here?
The translator was counting his chickens, none of them hatched but
already squabbling.

4

The translator wanders into Babel and books himself into a cupboard.
Two languages on the same floor of Babel. – I was here first. – I'm not
talking to you. – Keep the music down. – You call that music?
But the gardens of Babel? Who talks about them? Who planted them?
Who tended them? cried the translator in his cups, slurring his words.

5

The blind translator had developed his sense of smell to an exquisite pitch.
He could read books the way a dog reads lampposts.
The blind translator felt his way through the book, knocking whole sentences
over. He'd have to build it all again by touch.

6

A poet and a translator walk into a bar. Give me a beer, says the poet.
I suppose you'd better give him a beer, says the translator.
The translator was admiring his dead poets. Not that I am alive myself,
he remarked, but at least I keep moving.
Several lungs, several breaths, several sets of teeth, several lips: we are several,
says the translator. We are several, echoes the poet.

7

The Lamentations of the Translator, pondered the translator. Dirge? Plaint?
Interpreter? Let's just call it The Giraffe's Birthday.
The translator was tracking the bear but kept wondering why the bear
was wearing his shoes. Bears are thieves, he muttered.

8

Two translators meet each other, examine their teeth. Whose teeth are those?
they ask.
To meet a roomful of translators is like meeting a charnel house of saints,
everyone a St Teresa, said the doctor.
They lined up the translators and shot them. Which one was the poet?
asked the soldier. Fourth one along. Maybe fifth. Not that it matters.
The translator lay dead but they buried someone else. Then they brought
in someone else.
The translator's arthritis was killing him. The dead lay round the room
like a compound of his own glittering bones.

9

We are legion, says the devil. We are the foreign legion, answers the translator.

10

Pentecost, shmentecost, shrugged the translator. Just give me the crib.

This short story was first published online in *The White Review* on 19 December 2013.

George Szirtes (b.1948) is a Hungarian-born poet and translator living in Norfolk.

Something Went Wrong

Keren Cytter

I print everything I write: emails, notes and Skype conversations. I scan my doodles and drawings and print them on both sides of the paper. My apartment is stacked with papers. I place them in green boxes and mark them with the date. At the end of the day, I connect my iPhone to the computer, upload, save and print my text messages, as well as the routes of my strolls and the pictures I take. I print my bank transactions, tag and scan my receipts. My computer (just like my apartment) is a library of text, still images and videos. I film whatever I see and whomever I meet as much as I can. I record conversations and phone calls on a small tape recorder. When I leave my apartment, I carry an iPhone 4s, Canon 7D camera and an Olympus VN-702PC digital voice recorder. My approach is clumsy but the results are satisfying. I back up my computer once a week. Surveillance cameras are placed above my bedroom door, the entrance door (pointing to the living room), the kitchen and the bathroom. They are connected to a monitor that's placed near my bed. The image on the monitor is split into four. The footage is captured and stored on a hard drive.[1]

My deadline is due in less than twenty-four hours. I'm writing these words just before sunrise. At night I took out all the files, hard drives and notes and lined them up chronologically on my bedroom floor. The window on the right side of my bed is partly open. A cold breeze is blowing through it. The monitor on the left side of the bed is running.[2]

I archive the materials at the end of the day. It takes between one or two hours. When I wake up, I email my dreams to myself (if I've had any). My state of mind is quite elusive, so I make sure to document every piece of information my mind and mouth are producing. When my thoughts turn into a sentence, I write them down with a pen in a notebook. They are typed and filed at the end of the day.

The stacks on my bedroom floor (at the far end of the room, near the closet, next to my bed) are dated from September 6 to the present day. Each stack is a detailed documentation of one week, and reaches up to fifty centimetres or more.[3]

[1] The sound of buses departing from the station is heard. The Port Authority Bus Station is the first to wake up in Hell's Kitchen.

[2] There is no movement in the rooms. The bathroom is empty and dark. There's a light in the kitchen. The dishes are standing in the sink still unwashed. In the living room the couch is spread open on the floor. A body is laying on it covered completely with a great blanket. Two cans of beer are resting on the desk next to an ashtray, rolling paper, a white plastic bottle, a small tube, a bowl, and torn business cards. In the bedroom, I can see myself sitting in bed with the laptop on my hips. The lamp light illuminates my profile. My back is hunched, squeezing the pillows that are tucked underneath.

[3] The sun is slowly rising. A flock of pigeons is seen in the distance circling the far neighbourhoods near the curved bridge to New Jersey.

The reason I focus my investigation on the documents going back to September 6 is the reason that made me transfer the archive to the bedroom: a guest named Tal H. I've known him for more than a decade. He called me five months ago, and asked for a temporary place to stay. Apart from his suitcase, which accompanied him on the day of his arrival, he indulged in the purchasing of an electronic piano and a couple of speakers. These objects forced the shift of my possessions from the living room to the bedroom. It's already been more than three months since his arrival.

Tal H is a jazz player. He smokes a dozen joints a day. The neighbour across from my apartment knocked on the door one time and threatened to evict us, or at least to report Tal H to the landlord. To little avail: Tal keeps his dubious habit, and I was never evicted. I doubt whether the landlord was even informed.[4]

On Tal H's arrival (September 6) the top of his head – getting slightly bald – is seen through the monitor. He's holding a small plastic bottle of Ritalin, claiming it helps him concentrate. I'm heard saying (metallic and cold): "I don't believe in unnatural stimulants."[5] On another recording (October 8), we're standing almost at the same spot as the previous recording. My arms are crossed as I mumble, in a low voice, a long and incoherent argument. (The mic attached to the camera couldn't capture most of the speech.) "You are trying … always … If it's … your mother … you … if I … not to compare to … sure do." Tal is seen moving nervously from side to side, as he finally answers: "You're a hypocrite." Then I'm seen scratching my nose, walking to the bedroom, and I'm out of the frame. I can see from the monitor near my bed the plastic bottle on his desk next to his computer, twinkling from the screen like the Northern Star.

It's midday and the sun rays are stretching slowly through the window, illuminating my back as I sit on the floor and go through the files.[6] I follow my life as if a stranger, but no event captures my attention. My habits are common and considerably repetitive. I recognise a few slight changes in my daily routine – throughout September, my hours of sleep were reduced from six to three. I notice that I'm hardly emailing my dreams anymore.[7] The last email was sent at 5:43 am on September 23:

> … I was on a skateboard rolling so fast that fire was coming out from the wheels, I didn't stop at the traffic lights and a voice was telling me that I belong to a special family and 'with great power comes great responsibility'. I was rolling in the streets at full speed, almost falling but

4 The first flock of pigeons are passing by the window.

5 Another round of pigeons is passing by. They fly above the building's roof.

6 Tal is moving his head and pushes down the blanket. Then he's turning around and lies on his back. He's raising his arms behind his head and he's staring at the ceiling. I can hear him cough.

7 Tal opens the bathroom door. He's standing above the toilet and pees. Then he is taking off his clothes and throws them outside the frame. He's getting into the shower. I see his hand peeping out and grabbing the toothbrush and paste from the sink. Steam covers the lens. The living room is empty, the couch is folded and the blanket is thrown in the corner of the room on a pile of clothes.

never crashing — nothing happened. I watched myself from above. I almost flew away because of
the speed. Then I reached a desert. There was something in the middle of the desert I shouldn't
have landed on. So (I'm now inside myself, I don't see it from above) I jump high before the road
finishes and fly (not really) above the desert. I fly so high my heart is leaping out of my body.
The sun is yellow and I'm free. I'm passing the obstacle I need to pass, but because my skateboard
is fast, I keep on getting higher and higher, twirling in the air. Losing control but I am safe.
My landing is fun: I dive into the warm sand. No pain. I see from a distance some dogs eating
bones and wagging their tails and I'm happy: Mission accomplished.

That's one of the last written evidences of happiness I encounter in my
research. Most of my diaries indicate an increasing dissatisfaction with my life
and particularly with Tal H. Our interactions are rare, and on September 10
I start shifting the green boxes into my bedroom closet — a process that will
be complete only on September 21. Traces of bitterness, and a grudge towards
Tal H and the world in general are spread throughout my diaries.[8] At the
end of September I notice an increased tendency to detail as I transcribe my
recorded conversations. Now all dialogues and impressions are filed in two
versions — literal and visual/audible.

In this period, Tal H and I quarrel quite often, almost every day. We focus
on three main subjects: cleaning, dependency and addiction. I disapprove of
his constant use of marijuana and Ritalin and question his talent. In response,
he calls me a nutcase and a hypocrite. I'm not surprised by his response. Denial
is a necessary instrument in the psychological structure of a jazz player.[9]

The deadline for this text is due in less than twelve hours. I search for
something to hold on to — I look for something to search. The archive is filled
with notes and maps and I'm trying to find patterns in the flocks of pigeons
that are passing by my window. They're nesting at different spots in the
neighbourhood. I circle their placement on the map and mark their movements
with rounded lines of arrows similar to the ones that indicate directions
of airplanes in flights.

In the midst of the research, at the end of October 23 and before opening
the folder marked "October 27", I promptly rise from the floor (right leg is
asleep) and leave the apartment for a short stroll.

The winter sun seems reinvigorating. After hours of detailed investigation
in the static cloud of my daily routine, I open the entrance door of my building
and let the icy breeze wash my face. My eyes are locked on the street like a

8 A police car just passed with a distorted
sounding siren. It slows down in a small
traffic jam — the siren is on full volume.
After a minute (it feels like a lifetime)
it is driving away.

9 The sound of the running water in the
bathroom just stopped. A dark figure is getting
out of the shower. The bathroom door is open

and the image is getting clearer: Tal H is drying
himself with a towel. He wraps it around his
waist and walks away. The bathroom is empty.
The light is still on. He is passing the kitchen.
The light is still on in the kitchen. Tal is in the
living room. He's picking up clothes from a pile
in the corner. He hangs the towel on a speaker
as he dresses up.

starving dog staring at a bone. I cover my ears with headphones and wander the streets aimlessly, letting my mind connect and dismiss different possibilities that might lead to a certain validation. It's impossible to walk aimlessly because of the natural bustle that is pouring out of Times Square to Hell's Kitchen and the nearby neighbourhoods.[10]

I stop in a noodle restaurant near the Port Authority Bus Station. Four lonely people are sitting at the bar, hunched over their bowls. While waiting for my dish, I'm spinning the bar chair slowly from one side to the other. I check the photo roll on my iPhone again. The upcoming deadline is casting a shadow over me and my body turns to a sand clock. The Tabata Ramen is served with a side salad. My deadline is due in less than twelve hours.

As I dig out half of a partly boiled egg, I suddenly experience a clear understanding of my actions. All the pieces fall into place and build a coherent narrative. That's what I was looking for! An unbelievable amount of adrenaline gushes through my blood. I rush outside, headphones on my ears (the sun is saying "Hi!"), clutching the sticky plastic spoon in my right hand. The air is made of ice. The street welcomes me back. The wind is soft and yellow.

While scrolling down the photo roll I came across a video of a flock of pigeons circling the sky. The camera was placed on 10th Avenue and 41st Street – a deserted office area, neighbouring the concrete tunnel to New Jersey. I could see my apartment window in the background. At one point in the video (at 2:37) the camera abandons the flock and focuses on my bedroom window. The pigeons were marking the point that connects 10th Avenue and 41st Street with my apartment.

The back of Port Authority is under the grey concrete tunnel that connects Manhattan to New Jersey. The entrance is partly occupied by homeless people and passers-by. I watch them and wait patiently. I trust my instincts like any other living organism. I shove the plastic spoon in the pocket of my coat and the mp3 player switches on (by accident). I hear Let England Shake by PJ Harvey. The cold sun, my loyal coat and the foreign view of the station bring Sting to my mind – an Englishman in New York. It's not a coincidence.

On September 24, Tal H mentions a concert with Sting and Paul Simon that is about to happen in Madison Square Garden. There's nothing more to explain. I rush home (three minutes away) and climb up the staircase, skipping every other step. Tal is standing in the kitchen. I can see the top of my head in the bottom of the screen (the upper right side of the monitor). He turns to me and asks where I've been. I answer, "Outside" and ask about the concert. He doesn't remember. I add "Sting and Paul Simon?" It rings a bell. He answers: "It's not tonight, it's in March, and I didn't buy the tickets, you said it's too expensive." The conversation ends immediately. My head disappears from the screen and Tal H turns his head and leans on the kitchen sink.

10 Grey clouds arrive from the east and cover
 the sky. Few drops of rain.

I'm back in the bedroom and carefully study my close environment.[11] There's nothing noticeable, my routine as lack of routine is consistent. My thoughts are predictable. My lifestyle is basic. I'm kneeling over the material bored and distressed. The presence of these two states of mind (boredom and distress) is violent. I'm yawning (reading) while my hands are trembling (clutching documents). Then, a moment before boredom takes over, the ground under my feet (mostly my knees) starts moving as I read an alarming poem from my iPhone written on November 29:

> *Waking up in fright*
> *Waking up after a hard night of Ritalin*
> *is like waking up on a desert island:*
> *I hear the waves, the foam on my skin.*
> *Something happened —*
> *The skyline is bleak*
> *The worst is behind me*
> *at least for today*
> *Good morning world!*

Pandora's box is open. Its content startles me. I read the poem several times. I mainly focus on one sentence: *after a hard night of Ritalin*. I read it over: … *a hard night of Ritalin*. And over: … *hard night of Ritalin*. Especially one word: *Ritalin*. Yes. *Ritalin*. I read it over: *Ritalin*. The Northern Star is shining. I stand up (both my legs are asleep) let the blood run, lose my patience and sit down. I connect the hard drive to the laptop. My hands are trembling. I'm not bored. The surveillance cameras are exposing the apartment once again. The Ritalin bottle is laying on the desk as always. I lay in bed as I always do. Tal is boiling water for coffee in the kitchen. Then he goes to the bathroom. I see my figure standing up (my back is hunched, I'm much thinner than I feel) and enter the living room.

The recordings show that since September 11, I have been consistently consuming Tal H's Ritalin pills. By the end of the month, I double the amount. By November 10, the amount is tripled. Traces of my interest in the side effects of the pills are found in almost every file, every day. On October 4, I dedicate a folder to Ritalin and its different names and dosages. Tal H is aware of the situation. He accepts it with stoic resentment. A clear indication of this state

11 Tal H is entering the bathroom. He sits on the toilet and is staring at the camera. The lens is still wet from the steam. The kitchen is empty at the bottom left side of the monitor. I enter the living room at the upper right side of the monitor. I look to the sides then my head appears for a second in the kitchen. I turn off the light. I'm back in the living room standing by the working desk and open a white plastic bottle. I spill the contents into my right hand, pick up a pill and then put them back in the bottle. Back in the kitchen my back is seen as I fill a used glass with tap water and swallow the pill. I turn the kitchen light on, open the fridge and after a minute I open the freezer. After a short hesitation I slam both doors and leave the kitchen. I'm passing the living room and enter the bedroom (upper left screen of the monitor). All that time, in the bathroom, Tal is staring at the camera.

can be found on November 12: After I pick up the pills from his bottle and go back to my room, Tal comes out of the bathroom, approaches his desk and then turns around staring straight at the camera and raises his middle finger. The gesture is powerful.

I noticed nothing. I was blind, in denial, for over three months. My eyes can't be trusted. Lies surface through all the texts and footage I collected. The stacks of papers, once an existential triumph, now resemble a social decline, a half-baked alibi of a simple drug addict. I follow the footprints of an aimless vagrant chasing its tail.[12]

My deadline is due in less than four hours. More lies are recovered; contradictions are piling up. I watch my body lay in bed throughout the day. The time runs along the bottom of the monitor – square numbers on a white strip. I didn't leave the bed (go for a stroll, stop in a noodle restaurant) since writing this text. My body gets out of bed and disappears for a moment from the screen as I pick up the coat from its hanger. I'm back in the frame, sitting on the edge of the bed, searching for the plastic spoon in its right pocket. The following items are revealed: two crumpled cab receipts, a wallet with a blue debit card, headphones shaped as earplugs and a passport.[13] I plug the monitor into the cameras.[14] I detach the monitor from the cameras and rewind the last minutes. Another lie has been detected: I didn't reach for my coat (although it was hanging on my bedroom door, I swear!).

I'm lying in bed as I did the whole day. I keep on lying in the bed and wait. I wait forever. To this moment – I wait.

My deadline is due in one hour. I look through the window at the flashing street signs that are reflecting on the building's window from across the street. A cold wind is blowing through the window. Temperatures are sliding down. The buses stopped departing from the station.[15]

12 The sun is setting and the streetlights are on. The skies are bright purple.

13 Tal is sitting next to his desk with a cup of coffee. His back is hunched while he's looking at the screen. He types quickly in short sequences and then pauses. Then he leans back, stroking his head with both hands and messing his hair. He keeps staring at the screen.

14 The window is dark. The night washes the street and the sound of pedestrians taking the lead. A woman is heard screaming "Taxi" and after a moment laughing out loud. More women are laughing. Soft hip hop music dissolves to one of the roads crossing my street.

15 An ambulance just parked next to the building. A few cops are standing by the Irish bar under the apartment. Colourful police lights illuminate the street and the bedroom's walls. Another police car is parking on the side pavement. A woman is heard crying: "Doooon't tooooouch me! Don't tooooouchh me!" A cop that's pulling her out of the Irish bar holds her. Two cops are standing behind him. She cries "I said – don't touch me!" The cop is letting her go and she's making her way back to the bar. The cops prevent her from entering and she cries again in a long drunken tone: "Dooooon't tooooouch me! I said don't tooooouchh me!" They slowly bring her to the ambulance. The second police car is driving away. Tal is in the living room, leaning on the windowsill. His head is out of the window. He stays that way. Two minutes later he's walking in the room smoking a cigarette. It seems like he's talking to himself. He sits next to the electric piano and covers his ears with big black headphones. No sound is heard while he is playing the keyboard. His back his hunched and his head moving softly, concentrated, from side to side. The doorbell is heard. First just a single ring and then a chain of angry repetitive buzzing. The apartment is suddenly filled with frantic doorbell ringing. It reaches the bedroom, the kitchen and the bathroom. All the lights in the apartment are on.

Keren Cytter (b.1977) is an Israeli-born artist living between London and New York.

In Tansu

Karl Larsson

I

corner and fold

align

where would you place it in a room?
where would it be placed by its people?
the blank space for money,
ornamented inkstick and seal

caught in calligraphy is a time
when characters would bleed into one another
their days were darker
no, darker still are our days
of performing as assistant spectators,
spinning off into durable and fair – good overall conditions
for sale is a Japanese Edo era wood money box
with iron handles, hinges and locks

by looking one will notice detail,
by noticing detail one will attain precision
this 200+ years box has breakage, missing parts
nicks, scuffs, marks, cracks, rust, wear, dust and
further in the description of the object
on an auctioneer website
one will also notice how it has been taken care of
by somebody who truly seems to enjoy her work
who offers 18 large images
and a detailed text bulging with adjectives
re: a blackening old box
moderately priced at 75 dollars

absolute, wealthy world
full of images

part industry,
part robotic English,
as a result of a forced translation from Japanese
to read the appearance of an object
and its direct relation to the word
which was once agreed upon to be its allegorical prison

with allowing ease,
with the body,
which from all the borders of itself
must know that every form is a small excitement
and the everyday treatment of it
a small disappointment

in a history of quotations
and documented excerpts

people
dragged out
with clinical strength, not desire
from agitation points

military positions, operative rooms
salles blanches
into whatever

toolboxes and furniture
readers, buyers
and collectors

to give progress a name
installation art, institutional critique
and add love to the gaps and punctuation marks
museum, gallery, oil, subject,
composition, image, privilege
there is a source to everything
quote and return to datum

there are objects in-between indexes
like paper, destined for currency
now fold what is ours into deeper fracture
we were looking for something common
what was it?

Japanese Edo box, not at all rare
like a melancholic, almost mandatory yearning for Tokyo
after visiting the Shinjuku Gyoen in late November
where the long, yellow grass outside of the archer school
pierced and entwined a golden sweater

unlock
the broken cover
which is missing detail
and corroding (like a silver bridge)

assistant spectator, paperweight
there are no borders in an object

dark evacuates from dark
becomes a crate, a box
what is left of ontology
is still on the outside

the clear and almost embarrassing
shine from all colours trapped inside
the black varnish which can't even hold on to the surface
but falls in flakes in a potential customer's hands

II

we come see it and it is black
we leave and come back – it is black

the empty room, home or gallery
just makes us laugh

a night full of dreams
little metal circle spin
a night full of boxes
nothings

what used to be an abstract painting
is now a workbench or a chessboard

reading some words without alternatives,
like shoppers

and this is truly painless, yes
to stop and ask what is progressive
will probably not happen

the fan is making the room warmer

where are we?

the mattress is making the floor softer

ok, where are we?

assuming Berlin or New York, maybe London

what are we doing?

we should really try to buy this old Japanese piece of furniture

why?

it would suit us

is it expensive?

no

and the shipping?

that's part of the excitement

ah, ok

yeah

to belong to a class among other classes
the verb, the art historian, the rolex

while producers of the capitalist world-economy
are losing the optimism of the oppressed,
and must find a new hidden stabiliser of the system

ask around, look
some share a wish to not have been dead for so long
to not have lived, to not have been stuck
under the ground for so long

and some enjoy music
little cymbal in a cup
of two almost worthless coins

what went viral
in privacy
when his hand touched her hand
and her hand touched the screen?

what was
very, very close,
almost there?

very close
(as if)
almost there

we were told
it must be constructive and formative to work
and to know this as one would know one's own denial

then separation, alienation
irritation, frustration, refusal, rage

something stopping us from doing our jobs

citizens, foreigners
workers, consumers, students, rage

how could we become the people who could do our jobs?

a display of surfaces and bodies scaled up or down
becoming acceptable
in correspondence with their conditions

and do you know what we could see
when we focused our gaze a little?

an inclusion of you

ok

fourfourtwozerofourninesixandthatsacapitalgeeandzed

got it

andthatsseventyfivedollarsplussixtyinshipmentreallysixty?

ouch!

toolatenowwhendowegetthisarrivalcanyouread?

... two weeks

makesuretogiveitsomespacethen

yes, getting rid of the junk over there

III

sensei and pue we

people

a prehistoric time, fern
where volume pushes forward
into a folding fabric
turning slowly towards itself
until it reaches the point
where its borders are touching its centre
and the density of the inside and the outside
of what used to be an object
coincides

this morning,
a very mild torture,
like non-smoking

ignition, in a time
when the blackness of our future forests
rests as isolated ideas
in terrestrial poverty vaults

not too long ago buildings
were made out of glass

into the vegetation
psycho scratching, jumping back
there are some very elementary things
chilly winter morning
without winter

hungry, starving
little raw black source

words in a notebook
early grammatical attempts and errors
he do you do? what is colour?
you scum

you little dead
compartment for writing equipment
credible exhibition
compartment for money
in the backyard growths of history
some career paths are very slippery
what just recently made us enthusiastic
is now making us hesitate

hidden, upstairs at Starbucks
speaking of property
in front of a masterpiece
not feeling comfortable at all
letting greatness slip away
to triviality, come baby

down to where we can be
with others, just like us
with drinkers, workers
bartenders, builders ...

what can never be foreseen by a government or corporation
is the growing feeling of alienation
among its citizens, employees or consumers,
the initially not so unpleasant feeling of being slightly lost
(just a little less engaged than before)
will naturally gain in strength
and become cold memories, boredom

remember this
snapshot just a moment ago
of a girl drinking beer with soda
in 1992

and cheap digital cameras
of past seasons
taking pictures outside of the Louvre
and add small black frames
to treasure

do you like
well-lit faces on flat surfaces
relationship lost, detail gained?

and strangers,
looking as if they were laughing in oil
with faces shining from underneath a glossy varnish

red cheeks, drunken gaze
are they really serious?
do you like to follow?
to watch be watched forever?

gone
and
notification
fair—good

on an auctioneer website
yamajack, based in Fukuoka, has 6080 stars
money calligraphy box #20
was not sold at the expiration date (16/1)
and has been added as a new item
in yamajack's list of objects for sale
it is no longer possible to interact with an expired auction
clicking the link will trigger error messages
but the old photograph remains, it is different
from the one used to promote the new auction

sometimes flip, sometimes flop
or just falling through the months like a bastard
expression creates being
to buy, browse, live by the law
there is furniture in Kyoto, in Fukuoka
Kokura, Yao, ward Minato Ku
walls made of paper, boxes and chairs
tables made out of glass, paper
made out of poetry, metal scraps in the basement
of an aging sculptor in Maastricht
moulds and animals
will sometimes in an instant, like a cheap flash
wrestle our anxiety,
groveling eels, ink bowls, spit
and touch the depths of perception
before it stirs the surface

in Tansu
a girl is running
from the back of the train
through all the coaches

later in the day
jumping out of boredom in the aisle
at 30000 ft

sometimes better days
were those of apparent humiliation
no money, no way out

just waking up to an explaining light
and speaking very little at breakfast
to keep nights rare sights and hedgerows
of primordial vegetation
in the outskirts of the fading day
for a little bit longer

bring down leaves and dried fruit
to the soggy garbage soil
where four walls of a simple home office
constitute a house of writing
start printing work
unnecessary and unusual
with a long introduction, discarded at a glance
metal apple
old mac pro
waiting at the sound of the machines
taking shortcuts into thinking

on an auctioneer website
yamajack, based in Fukuoka, has 6080 stars
faceless, weeping 6080 stars
in the centre of the room walls are now introvert shadows

tools like a small wood money box
will keep value, rust, wear, dust
and be as profitable as remembering what you just read
32 × 21 cm of sea vault
sea because it is overseas
vault because it is archaic
then see what, weather, sound,
soft embraces of love, yes luv,

not the actual, horrid object

many
works
dry land

even more
never reach
exhibition

home object, written of
thought of, unsold
never auctioneered
pray (this word, somebody):
want

and all the time
writing, reading, accounting
for the brilliance
in this

and many other
beautiful things

Karl Larsson (b.1977) is a Swedish artist, editor, and poet living between Hamburg and Kristianstad.

Eddie

Anthony Huberman

For breakfast, Eddie would usually have two cigarettes. He took a short pause
between them, almost an entire minute, to give a chance for the smoke to
dissipate around the entire room. It was too cold to open the window, but
he preferred it that way anyway – cigarettes were a companion to him, so
he found it somewhat more honest and appropriate to allow them to inhabit
the same space as he did, and to feel like they could make themselves at
home there. Eddie's the kind of guy who would light a cigarette in a museum,
if he really liked the show.

The smoke made the room taste like hot milk – thick in texture, distinct
in flavour, but bland enough to hold other flavours within it. Eddie found it
not only comforting, but useful. He suffered from a slight form of haphephobia
(the fear of touch) and the smoke coated the room with a familiarity that
smoothed out all of its objects, making them less sharp to the touch. He had
learned this trick from listening to I am Sitting in a Room, 1969, by Alvin Lucier,
who did something similar as a way to handle the fact that he suffered from
a slight stutter in his speech:

> I am sitting in a room different from the one you are in now. I am
> recording the sound of my speaking voice and I am going to play it
> back into the room again and again until the resonant frequencies of
> the room reinforce themselves so that any semblance of my speech,
> with perhaps the exception of rhythm, is destroyed. What you will hear,
> then, are the natural resonant frequencies of the room articulated by
> speech. I regard this activity not so much as a demonstration of a physical
> fact, but more as a way of smoothing out any irregularities my speech
> might have.

Eddie found that sitting in a room, smoking, he couldn't tell whether
the room contained the smoke or whether the smoke contained the room.
No matter how impervious it might be to smoke, it was clear that the room's
own interiority was affected by what is put into it. Either way, the habit and
the habitat moulded and shaped each other. Rooms and cigarettes make a
good pair, he felt, even if his wife, children, and friends disagreed.

His kids lived elsewhere by now, and his wife Rebecca wasn't awake yet,
so he smoked quietly. If she woke up and came downstairs, she would almost
certainly open a window and go have her morning cigarette outside on the
balcony. They would probably then end up having another conversation about
bad habits, good habits, and so on.

But it's not always easy to distinguish bad habits from good ones. The Canadian poet Lisa Robertson has noted that "we are furnished by our manners and our habits" and that "a room situates the cadence of habit." [1] Habits give a heartbeat to their habitats, but are still contained within them, like an organ within its body. In that sense, a habit is also a spatial expression of its habitat. Robertson refers to a famous phrase by Gertrude Stein – *paragraphs are emotional, sentences are not* – and proposes that it be adapted by saying that "a room is emotional, an object is not." If a room is emotional, so are its habits, "not because they express an emotion", to quote Stein again, "but because they register or limit emotion." [2]

Instead of covering his fridge with dozens of reminders, magnets, and stickers, Eddie kept just two things on it. The first was a photograph by Lucia Moholy (László Moholy-Nagy's first wife) called *Untitled (Walter and Ilse Gropius's Dressing Room)*, from 1926. It shows an empty room with a few closed doors, but where one closet door is open, revealing a single pair of white high-heeled shoes amid three shelves of dark shoes. The original photograph is just 4 by 5 inches, and so was Eddie's reproduction, but the composition and perspective make it so that the image seems stoic and confident, without being monumental. It is graceful but also rigid, like a dancer holding a perfect pose.

He kept it on his fridge not because it contains homely warmth, but because it offers something that could be called a sovereign intimacy. [3] As a public image, it is still in control of its own privacy. As a space, it knows how to maintain its small scale. And as an idea, it believes in the assertive power of one's immediate surroundings. Despite the small size of the photo – or perhaps because of it – a dressing room becomes a type of fortress, defending the experience of being outdoors by staying indoors, and vice-versa.

The other thing Eddie kept on his fridge is a postcard, which is actually a letter. It said:

Dear Jelly,

It's time.

Best,
Peanut Butter

He couldn't quite make up his mind about whether it was about sandwiches or about sex – which almost certainly means that it was about sex.

He opened the fridge, took out an apple, washed it, and took a bite. When he was done, he poured himself a glass of juice, lit another cigarette, and walked over to his desk to check his email.

Eddie checked his email while he was still in pajamas. That morning, he was amused to see an ad on the sidebar of his Gmail account that asked, in flashing blue letters, "Are you wearing pants? Wouldn't you rather be wearing pajamas?" It was another ad for a job that lets you work from home. In fact, there was a long list of them on his screen. No Experience Req. Earn $19–$24/Hr. 9 Positions Available. Apply Now. Sell Promo Products. Full training, tools and support. Earn Money on Your Own Schedule. Eddie reached for another cigarette.

Many have written about the pressure to perform. The nonstop nature of contemporary capital demands a never-ending "Yes, We Can" attitude that stops at nothing. Work is in the water we drink – it's always already there. And to distract ourselves from our day jobs, we do some work for Facebook and Twitter, providing them with the content they need to exist. In other words, when we don't work, we work. The question, naturally, is what does one do about it? How does one disagree? Or, to make the question more specific, and make our ability to answer it more realistic: What does Eddie do about it?

Guy Debord's *Ne Travaillez Jamais*, scrawled on the side of a Parisian building in 1953, struck Eddie as somewhat dated, although still incredibly sexy, a bit like the Marlboro man. And Bartleby's *I would prefer not to*, much theorised by many, seemed to him like exactly the same thing, a bit like Robert Redford cast to play the defiant rebel in two different movies – in one he's a cowboy and in the other he's a dandy, but everyone can tell that it's the same person playing different versions of the same role, adapting it to fit the plot of the narrative his persona inhabits. And Hans Ulrich Obrist's *dontstopdontstopdontstop* was certainly not the way Eddie wanted to live his life – he liked smoking too much, which is all about stopping and taking breaks. No, to him, there was an aphorism by Jan Verwoert that made sense: *Give what you don't have to people who don't want it*. There's something in there that corrupts the very norms of productivity themselves,

injecting them with an equal dose of excess and deficit. It's about providing unconditional and unwavering dedication to accomplishing impossible or unnecessary tasks – and then giving it all away for free. It's a positive form of delinquency, or an inefficient efficiency – a way to work that doesn't fit any economical model.

Eddie needed to leave for work soon, but he wanted to spend a few minutes working on his coffee machine, which is why he had gotten up so early. He had spent much of his free time over the past few months disassembling and reassembling it, and he wasn't done yet. It was a simple appliance, on the surface, with just three buttons: on/off, long pour, and short pour, and the slot for the capsule of coffee. Eddie liked his coffee short, ristretto. What he didn't like, however, was the fact that the long pour button was positioned in between the on/off and the short pour buttons. It was a button he never used, and would much prefer being able to turn the machine on and only having to slide his finger over to the adjacent button to start the pour, instead of skipping over a button, and risk hitting it by mistake. Several months were spent, then, taking the entire machine apart and re-assembling it in such a way as to reverse the order of the two pour buttons, so that short pour was in the middle, immediately to the right of on/off, and to the left of long pour, which would then be on the far right. The problem was that the buttons pressed down onto moulded silicon tabs that connected to a small circuit board, so changing the order of the buttons meant building a new circuit board. He designed it in CAD, printed it onto a blue transfer sheet, and then onto a copper-coated board. He prepared his tray of ferric chloride and warm water, and used plastic tongs to lay the circuit board in the tray, allowing the exposed copper to be etched away. Wearing goggles, he drilled lead component holes into the board, and, finally, added the electrical

components and soldered them into place. Since he had never done any of this before, he watched (and re-watched) dozens of YouTube tutorials. It took him a week to figure out how to open the machine in the first place, and since then, he must have built at least ten circuit boards, spilled toxic solution on several rugs, burned many fingers, and been late for work so many times that his boss had threatened to cut his pay. Rebecca was as excited about the new button configuration as he was, and was far more skilled with her hands, so her help had been instrumental. They were making good progress, and they were almost done.

Ding … An SMS came in from his friend Simon. *u up? what r u doing?* Nothing, he replied.

It was a difficult question to answer, so he had chosen the easy way out. What he was doing sat somewhere between productivity and non-productivity, at least in the conventional way those terms are used. He was not responding to any external demand, but was waking up very early to work very hard, and had the scars on his hands to prove it. He wasn't inventing anything, repairing anything, or repurposing anything, but simply doing something to an object. It wasn't a hobby, it was not very fun to do, and it had nothing to do with some kind of anti-corporate *Whole Earth Catalogue*-DIY activism. It had become a habit, perhaps, and came with a sense of purpose and necessity, mixed with dysfunction, as is the case with any habit – like smoking, say, or like eating yoghurt with a fork. No matter how minor, it defines a way of thinking and asserts agency over his own relationship to the world – one that rejects the normative and ethical system that separates time well spent from time badly-spent. It's a delinquent form of pragmatism, where time isn't money.

Rebecca and Eddie's kids knew all about the coffee machine, of course, and called it "a problem in a minor key". It was an apt phrase, especially since it was borrowed from Belgian theorist Isabelle Stengers, when she describes a way of thinking that functions in a "minor key", safe from the false plight of an "either/or disjunction" and from the impossible demands presented by Ethics or Truth, but home to a more pragmatic ethos where practitioners can determine how they live and how they spend their time. Following Deleuze, she notes that, "an idea always exists as engaged in a matter, that is as 'mattering.' As a result, a problem is always a practical problem, never a universal problem mattering for everybody." [4] Eddie and Rebecca lived in the middle of what mattered to them and to those around them, conducting a form of productive and provocative withdrawal, played in a minor key. He had another cigarette. Simon never texted back.

Later that evening, after dinner, Simon would be among a small group of friends who would come over to Eddie and Rebecca's house to look at a painting by the American artist William Leavitt. It was a work called *Mod Ville*, from 2012, painted with oil on canvas, measuring around 5 feet by 2 and a half. It depicts a driveway that leads up to the closed gate of a house or compound of some kind – only a single brown roof is visible from behind the white gate. The sky is open and pale, and there are trees and bushes alongside the driveway and

behind the gate, placing the house in more of a suburban setting than an urban one. It's probably near or outside of Los Angeles, simply because that's where the artist lives. All seems fairly ordinary except for the fact that the house seems to also have an amusement park ride on its front lawn. Emerging from behind the gate, next to the house, is the immense metal structure of a Zipper ride. The owner of this house, it seems, has incorporated the euphoria of exuberant physical entertainment into the intimacy of domestic and private space – not on television, or via Wii, mind you, but with the mechanical object itself. But all looks calm and routine – there are no people in the scene, no cars parked out front, no indications of noise, mess, or disruption. It's another American landscape painting, but where the wildness of social life and our obsessive search to escape into disorientation is on the front lawn, next to the garden hose and the family grill. It looks like a spaceship landed there, and while it is entirely able to take off and go elsewhere, it has taken to its new home, and is trying to fit in.

The painting had been hanging in their living room for a few years, and they had gotten in the habit of inviting friends over to look at it. Eddie would move the couch, Rebecca would set up ten or twelve chairs in front of the painting, and that was pretty much it. Friends would come over, sit down, and look at the painting together. They would sit there, in silence, usually for around an hour. Then, everyone would stick around for a whiskey or two, have some cigarettes, and go home. They would do this once or twice a month, and everyone enjoyed it a great deal, and would keep coming back.

There was something extraordinarily satisfying about *mediating the immediate*. [5] It inserted distance within the quotidian. It worked hard against habits, prodding them as if to see if they will break, or at least bend. [6] It followed Georges Perec in asking "how to expel functions, rhythms, habits, how to

expel necessity?" [7] And it did so from within the home and between friends – the most primary of habitats. Sitting together, they returned habit to a place of indecision.

But what they liked most about it was the silence. Silence and eventlessness are ruthless forces, but two things they do well are to stimulate the imagination and to eradicate competition – everything is possible and no-one can win. It's always nice to create a situation where everything is possible, but it's much more complicated to create one where no-one can win. Competition drives capitalism, and, in the words of Franco 'Bifo' Berardi, the project of economics is to reduce "the subject of human relationships to one single goal: competition, competition, competition." [8] And Bifo reminds us that competition means violence: "competition is the concealment of a war machine in every niche of daily life." [9] Silence, deceleration, and retreat into smaller scales and into one's immediate surroundings can disentangle a singular existence from the social game of competition and productivity. Executed in solidarity and complicity with others, it can be the poetic refrain that cannot be reduced to information. To pervert John Cage's famous phrase, it's about having something to say and not saying it.

One last cigarette, and it's time to go to work and for the needle to finally walk into the haystack.

1 Lisa Robertson, "Atget's Interiors", in: Johanna Burton, Lynne Cooke and Josiah McElheny (eds.), Interiors, Bard College, Annandale-on-Hudson, 2012, p. 39.

2 Ibid., p. 41.

3 This phrase is borrowed from the unsigned press release of the exhibition Another Castle, shown at Etablissement d'en face, in Brussels, in 2012. I think the artist Michaël Van den Abeele wrote the text, but it could have been Peter Wächtler.

4 Isabelle Stengers, "Introductory Notes on an Ecology of Practices", Cultural Studies Review, vol. 11, no. 1, March 2005, p. 190.

5 This phrase is borrowed from Vilém Flusser, Post-History, [1983] translated by Rodrigo Maltez Novaes, Univocal Press, Minneapolis, 2013, p. 165.

6 "Plasticity, then, in the wide sense of the word, means the possession of structure weak enough to yield to an influence, but strong enough not to yield all at once." William James, "Habit", in: The Principles of Psychology, Henry Holt and Company, New York, 1890.

7 Georges Perec, "The Apartment", [1974] in: Species of Spaces and Other Pieces, translated by John Sturrock, Penguin Books, London and New York, 1997.

8 Franco 'Bifo' Berardi, The Uprising, Semiotext(e), Los Angeles, 2012, p. 95.

9 Ibid.

Anthony Huberman (b.1975) is a Swiss-American curator and writer living in San Francisco.

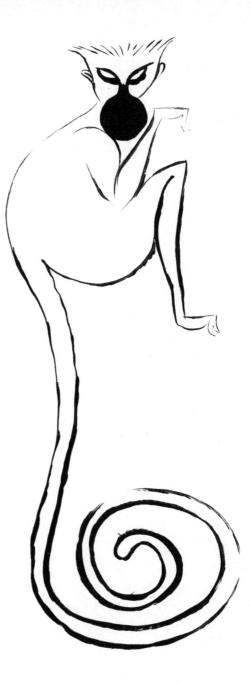

Twice

Eileen Myles

A friend of mine, Dana, was prowling around in the electronic proof of
a journal we both are in, *Maggy*, edited by another poet friend, Adam, and
Dana found my poem "What Tree Am I Waiting" which I will include here.
Now? Well, sure.

What Tree Am I Waiting

That whole part of the world
where I won't go any-
more
that whole separation
that I won't feel
high in this house
in this hemisphere
in this artificial light
that is artificial
in the earliest morning; dark
in pages and pens
in an unfamiliar bed
in the foot curl
furniture
each rumble
when morning comes
and it's still morning
and it's still night
I married a dead girl
we were born in her
bloom
remember that fat bumblebee
landed on a lamp
I opened the doors
and I forgot and the house
got colder and colder
where is this house
the seam between boards
merely gains my attention
it's dark and thin

I monitor each situation
my bladder growing full
climb down climb up
what tree am I waiting
my whole life in weather
waiting for my raft
I'll fly to another island
I'll take a train
already I know
it will hurt
this is the hurt country
I came here
to hold the hurt like a bird
like a tree
traffic has rings
we watch it whirl around
damaging our night
great continents hold
the feelings and the ages
what is mine
going blind
great masses of them
not going home
the country drew a line
because of memory
one said
I feel my heart race ahead
in eternity there is this ache
there is this wakefulness

Dana wrote me because he was very excited about this poem. He said he was "getting pee-shy (ha ha) about *my own thing*" (which was a joke since he describes among other things taking a piss and he wonderfully calls his own dick "the disaster of the world"). His explanation of why my poem was important to him was like balm to my ears. He wrote:

> To hear someone arrive with that purpose & then put it right there, getting out of the way of everything else to get it right to the top of the thought & the poem. That's the best stuff in the world to me, that sound. It seems harder than ever to do, or I'm confused right now somehow, regardless, it just tolled in the room for me.

This was huge praise from someone whose work I currently adore. I was pee-shy too about my own poem in particular because it was so emotional. How will it be received. Dana did refer to his own piece in *Maggy* as "a poem" which intrigued me cause it looked like prose. It's prose in a world in which I've never really noticed whether people describe Bernadette Mayer's influential early works "Moving" and "Memory" as poems or prose. Didn't she call it writing. I mean I think even for Lydia Davis genre is like gender in the poetry world. I'm remembering Amber Hollibaugh explaining gender this way once. It's not what you're doing, it's who you think you are when you're doing what you're doing. So prose writers in the poetry world always felt less like prose writers to us, more like fellow travellers and someone like Bernadette *was* probably writing poems that looked like prose, or like Lydia, prose in the poetry world which for a while at least adds up to the same thing. She was a fellow traveller for a time, and still is, truly, though she's also everyone's now. John Ashbery's greatest book I think is *Three Poems* which certainly looks like prose. So if Dana Ward wants to call his prosey looking stuff a poem it probably has more to do with how he feels about the work. Or *whose* he thinks it is. When I read it, it's mine for sure. I nipped off to his page in *Maggy* right after I read his email to see what he had in there. His piece with the pissing scene was indeed the one he had emailed to me last summer both as part of an extended hello and a particular greeting because his piece was dedicated to Maggie Nelson who he had just met up at Bard where they were both visiting/teaching. Maggie is one of my favourite people (and writers) in the world, and I think my name came up while they were talking and all of this triggered Dana's sending me the piece because he knew I loved Maggie and now he did too. And I mention both of them because if there are two youngish – they might be in their early forties but that is by now young to me, being 64 (will you still need me, will you still feed me ... No! was the answer but we haven't gotten there yet) – if there are two people whose work *everyone* likes, it is them. Maggie is also a poet who writes loose, splashing (or maybe slashing) speculative prose and though very different writers (Maggie's more on the balls of her feet, and Dana's loopy warm and risk-taking) they kind of describe a moment in writing in which a lot of things that people like are beginning to need to happen in the *same* pieces

of writing and those things may be gossip, theory, sexual description or simply an implication that *it's* there or just happened (art) but what's great is that while the most feeling-oriented scholars have been calling for this collusion for a while it's in the hands and minds and on the computers of poets that all this continental shift is truly happening. Poetry is the new space of possibility and everyone knows it. Maggie and Dana are two charismatic (and interestingly, both married) wanderers who are working the line between worlds while enjoying the road and packing light. (I think part of the method of their madness is security.)

One thing I want to say also at this moment is that everything I'm describing so far has happened on my computer. Or in it. Dana wrote me, and he had visited my poem on his computer. I visited his; I remembered encountering his last summer in Italy I think and I wrote him back and then I look at the letter from the Liverpool Biennial and then I look at Dana's email again and then I find a couple of poems on my computer and I begin.

So I wrote Dana back last night and started to talk about my poem. I don't want to say what I said back to him. I'll try and remember what I meant. I wrote my poem last fall. I had been with my girlfriend in Italy last summer and then she went back to New York and then I variously travelled to Lithuania, then Istanbul, and I called and wrote her from these places and finally I arrived in Ireland where I was to spend the fall. I went to Dublin, well Dun Laoghaire specifically where my friends Ali and Kathleen live and then we went for a trip down to West Cork and we took ferries to islands and saw two versions of the same play. In one version because we were late we had to stand ears pressed to the wooden door of the community centre under the deep blue sky and listen to Carmel's play being performed inside. It was a one-woman show in a small space and we would have entered right in front of the actress which just wasn't possible. The next night we were with the playwright herself, Carmel Winters, who was Ali and Kathleen's friend and now mine. Her actress had to go to a wedding that night so Carmel decided she would do it herself which she did in another small community theatre on Sherkin Island. We had been feeling her anxiety all day and I was truly nervous for her but she was tremendous – even bravely donning the same red running outfit as the actress. It was a dramatisation of a film she had earlier produced called "Snap" which was about sexual abuse. Pretty riveting and smart. When the writer performs her own text you can really feel what it means. The timing of the thinking is there. I really don't understand acting at all.

I left Kathleen and Ali in a couple of days when they drove me up to Annamaghkerrig, otherwise known as the Tyrone Guthrie Centre. Tyrone Guthrie was queer I learned. And so was his wife. It was a lush retreat with mainly Irish artists. The first night there was tough since the acoustics in the dining room were not so great and everyone had different Irish accents and everyone spoke very quickly and spoke even faster when they got to the end which was invariably a joke which I didn't get since I didn't know what that *word* was.

On the second night we all took a walk around the lake and just as we were approaching the house to hear some music my cellphone rang. It was my girlfriend. I explained that it wasn't such a good time and she said I think we better speak now. She quickly explained that her playwright friend, Adam, who she had been hanging around with in the month since we'd been apart was now her lover. I told her that maybe it was a good thing which she seemed almost angry to hear but I had this sort of cool elevated even relieved feeling. I had been sensing that something was wrong in the couple of weeks before, our calls getting shorter and shorter and I had even pushed her once about whether she still *loved* me, her behaviour was so odd and she sort of slid away from my question and didn't answer.

So this was the end of my relationship of four years. I sat in the music room with the other artists that night and was serenaded by a variety of songs that seemed consciously chosen to quell and palp my scrambling soul. Love … love will tear us apart … Peter sang at which point I heaved myself out of the room, sobbing at last. I think.

I mean it was a strange break up. Does it ever happen by mistake. I think we were meant to break up about now but no one could see the way. She found it. I certainly loved her but I'm old enough to think about that (in some ways), well, so what. There's something else about whether it works which kind of means besides loving, can you stand it. I couldn't. But then I could.

By October I was living in Belfast. I promise you I didn't tell Dana all this. I was living in a little gatehouse to an estate that was no longer there. Instead it was a gatehouse surrounded by streets and streets of similar brick houses and there was a leisure centre down the hill where I worked out and a giant Iceland where I bought my food. I had two wood-burning stoves and it was already cold and very wet. I was working on a book.

There was a couch that turned into a bed and in the largest room in the little gatehouse there was a giant loft bed and there I lay nightly in hell. I couldn't sleep. And I couldn't stop thinking about my girlfriend and that man, and I thought about how I wished I had broken up with her last summer or the spring that had just passed and then I thought about her with that man. And I had even been betrayed before by a girlfriend with a man named Adam. I felt biblical. Who was I. There is a point in suffering and I mean suffering as a repetition. When you can't sleep or you fall into that bouncy medium stage where the softening of sleep is beginning to occur and then the forbidden thought sneaks in like a tiny seed that bursts into flame but white flame and the blaze feels like day has bombarded the inside of your self, all light dripping down all the windows of your heart and your mind and you look at the ceiling and you look at the tops of the windows bluing across from you and you wonder where in hell are you. Your body goes surge, surge, energy pouring wrongly into all your muscles and joints. You are one hundred per cent alive. Wrongly. You are so filled with energy and you'd like to kill and you don't want to kill yourself. You don't really want to kill anyone. It becomes wordless. It's not even late. It's so so early like about 7 am, or 2 am. Who knows what

time it is. Something happens at this point. What I did tell Dana is that
the thing that's so funny about being a poet is that you write *sorts* of poems.
You return to sorts of poems which are sorts of energy. Each poem that really
happens and by that I mean one that was conjured in a state that managed
to find its own rhythm in something deeply anonymous about the self.
I think being a poet or a writer you've spent so much of your time processing,
consuming, really creating an alternative self that is entirely composed of
language so that there are precise speeds or toxins or organs in it that work
in concert with the state that you are in and can only neutralise your own
pain by vanishing into a song composed of exactly that timbre, or something.
I don't know what it is. It's just that I've vanished into kind of a, not trance
but dictation that utterly resembled the circumstances I found myself in but
by enumerating them I evacuated even from my own pain and wasn't so much
out of my body but in it in some other way, deciphering the details around me
like a breathing tapestry.

I wanted to say to Dana I wrote that one before. Not the poem but the sort
of poem. Tonight I was talking on the phone to Adam, and not the playwright
Adam who poached my girl but Adam Fitzgerald, a poet, and a confidante,
a new dear friend and the publisher of *Maggy*. Which is not named after Maggie
Nelson but nothing feels coincidental, but more incidental. I just wrote him to
ask what *Maggy* means. I was telling him I had been in this exact state another
time and it really… not so much *felt* the same but was made the same. Of the
same light. I was having my affair with Bernadette Mayer. *You had an affair with
Bernadette Mayer.* Yes, and her husband. *When was this.* 1981. I was a young drunk.
Well not so young. Kind of the same age my girlfriend was if you believe in
karma. And I don't. *No I don't either.* It went on for about five months. We weren't
friends before and we weren't friends after. She's tough. I was in love with her,
her husband was in love with me. It kind of ended because she was jealous that
he was in love with me. I don't want him. I wanted her. It was absurd.

One night when it was all over or beginning to be over I was in my
apartment which was about a block away from theirs. There used to be a diner
that I could go to in the morning if I wanted to watch her walk to work or him
take the kids to school. And I think Ted Berrigan used to sit there in that same
diner after staying up all night doing speed to watch Frank O'Hara hail a cab to
work. But I was alone in my apartment in this bluish winter morning. If there
was anything to drink I had already drank it. The window was all fogged and
I taped some pretty Christmas card to the window. It was corny but it looked
really nice. I wanted to copy the window. To be in charge. And we didn't have
cellphones yet. I still live in that apartment and right now in the web of vines
out my window there is one red leaf that won't fall. It's stuck and I've tried
to take its picture and you can't. Now it's snowing so I'm sure it's gone.

After I stuck the card on the window I just became an echo. I vanished
into my situation. I think it's the opposite of dramatic. If there's a gland
I've only used it twice to produce a poem. Here's the story:

And Then the Weather Arrives

I don't know no one
anymore who's
up all night.
Wouldn't it be fun
to hear someone
really tired
come walking
up your stairs
and knock on your door.
Come here
and share the rain
with me. You.
Isn't it wonderful to hear
the universe
shudder. How old it all,
everything,
must be.

How slow it goes, steaming
coffee, marvellous morning,
the tiniest hairs
on the trees' arms
coming visible.

I like it better,
no one knows

sweetness, moving your
lips in silence.
Closing your eyes all night.

It's so much better
disarming myself
from terror, and light
passing through
a painting I stuck
on a window
earlier, when I was scared.

It's great, it's really great.
Trees hold the world
and the weather
moves slow.

Even a body dissolves
and takes a place, incorrectly,
everywhere I would
like to nuzzle,
and plants a heart
in the world
voiceless.

I began knocking.
Ridiculous. Just to hear
your echo back,
arm against face

just to stop those fucking
trucks, my thoughts
of vanishing
into that sweetness.

Is it the same poem? It's the same life. The same gone person, feeling so
anonymous in her love. I remember the joke Bernadette, her husband (Lewis,
otherwise he would hate it) and I had which was what she said as we were
breaking up: that she was no one. No I guess we had this conversation earlier
when we were all in love. She was no one. I said I was anyone. He said it would
be nice to be someone. So when I missed her I wrote "I don't know no one/
anymore who's/up all night."

And we did stay up all night at first. Don't lovers always.

"Wouldn't it be fun/to hear *someone*/really tired/come walking/up your stairs/
and knock on your door."

So he's there too. So I'm the only one that's gone. I'm the only one now up
all night by herself. It's sort of like the afterglow of love is this person who can't
sleep. And, yes, eventually even she has to leave and that poem is her residue.
Just a puddle on the page of what she's felt.

Will this happen again. That planet took 32 years to repeat. I don't think
there will be another one, not by this person. No.

Not unless my mother dies and she will. She's 93. She's the one who reminds me
of both these intense orphans – alluring and abandoning, I wrap my life around and
then I get thrown out. This is it I'm sure. And I'm the baby ghost at the frosty window
while the computer plays on. "My uncle is a tuber," texts Adam. "Spring has a belly."

He's explaining the meaning of *Maggy*. I'm that little red leaf. The storm is over
and the leaf is still there. But you know what I mean. I'm directly defecting to that
planet's rings.

Eileen Myles (b.1949) is an American poet, art journalist, and novelist living in New York.

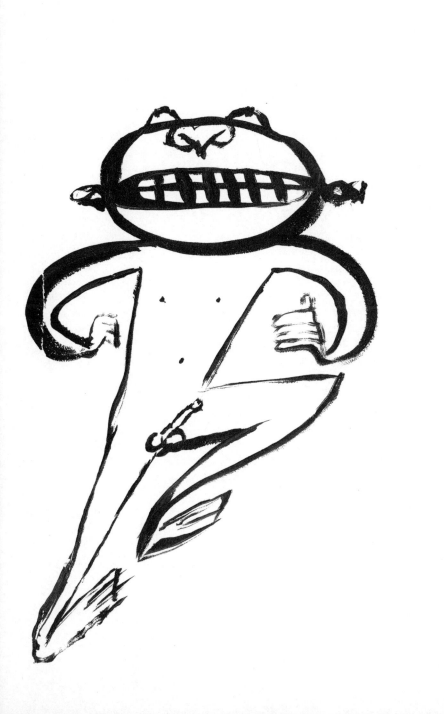

To Whom it May Concern:

Angie Keefer

Water inevitably finds the most efficient way to get wherever it's headed, which is always the same place, the place where gravity draws it, towards the centre of everything. Water flowing down a hill will run directly into an obstacle in its way if the path of least resistance leads directly to that obstacle. Suppose the obstacle is a boulder. Eventually, oncoming water will either undermine the boulder, or the obstinate boulder will succeed in splitting the flood of water into two smaller streams that gradually form trenches around the sides of the rock, hence cutting a more efficient path in the direction of gravity's allure. Suppose the obstacle is not a boulder, but something you would prefer to keep dry. Let's say it's your house. To protect your house from runoff, you would need to perform water's labour for it by digging trenches a few feet from the perimeter walls then laying a perforated pipe inside the trench and covering the pipe with loose fill. Water will seep into the fill, pass through the perforations, and zip down the slope via your pipe like a commuter on a high-speed train. This ingenious detour is called the French drain after its inventor, Henry Flagg French, who was born in New Hampshire in 1813 and spent his adult life as a lawyer, judge and public servant – he was even a United States postmaster at some point – not to mention engineer-agronomist-inventor and author. French published on the topic of his drain under the title *The Principles, Prospects and Effects of Draining Land with Stones, Wood, Plows and Open Ditches and Especially Tiles: Including Tables of Rain Fall, Evaporation, Filtration, Excavation, Capacity of Pipes, Cost and Number to the Acre of Tiles*, in 1860, when publishing norms dictated that titles fully inform rather than merely entice their prospective readership with regards to a book's contents. A few years later, French moved his family to Concord, Massachusetts, where they became neighbours of Ralph Waldo Emerson and the Alcott sisters, who reportedly cast a spell of enchantment over French's son, Daniel Chester French, then a teenager, soon to become a highly esteemed artist and, eventually, the sculptor of Abraham Lincoln's statue at the Lincoln Memorial in Washington, DC. Thus, the French drain and the Lincoln Memorial, which have no symbolic coherence, have a great deal to do with one another. The first leads directly though not significantly to the second. While directly insignificant relationships between objects, instances, people and thoughts are ubiquitous, they are almost impossible to discuss cogently. Insignificance operates like kryptonite against the superpowers of narrative. It weakens and destroys a story. "Insignificant" is another way of saying "opposed to pattern", is another way of saying almost nothing while still making sounds.

An aside on the French drain and Lincoln's statue marks the end, rather than the beginning, of the thoughts to follow. The association dropped anchor in the

front of my mind after a long period of seemingly fruitless meditation on the work of storyteller Spencer Holst, and serves as an analog to my experience of that work, a reading experience unlike any I can compare. I was delighted to be asked to write about Holst, even to write in a fanciful way to Holst in the form of a letter, some many months ago after reading just two short fables of his I found online, as one should be delighted to discover work with which she isn't already familiar and to be given cause to make something of that discovery, but as the winter months wore on, my delight grew dimmer like the days. Talking about the work of Spencer Holst is like extemporising on the relationship between draining the earth and cutting marble in the shape of a great man. The activity is surely possible, even supportable, but not necessarily sensible. Or maybe it's more like writing about music, a fine idea that probably doesn't do much for the music itself and definitely can't be well understood without the music beside it. That's because Holst was primarily a storyteller, secondarily a writer, while all we have left of his work is the page, which is like saying he was primarily a musician, secondarily an abstract painter, while all we have left of his music are his paintings. Writing and storytelling are not much alike. For one thing, a writer's audience is imaginary at the time of writing, whereas a storyteller's audience is a living, breathing, stirring, squinting, guffawing, booing, clapping presence. The storyteller is in live exchange with that audience, who will register and convey their degrees of boredom and captivation presently. And the storyteller's audience is watching and listening, which is an altogether different activity from reading, one that uses altogether different perceptual tools. Spoken words come through bodies – moving, gesturing bodies – and voices, and are unique to their bearers' physiques and existence. The written word, on the other hand, creates an illusion of permanence. It typically survives its writer, and can even appear anonymously. Printed words can, in fact, be destroyed or lost, but spoken words undoubtedly disappear as soon as they're heard, without producing any such illusion of stability. Holst's legacy of words is a small body of very short stories skillfully erected but half-abandoned with almost no deference to posterity. What remains on the page is more like a tower of pebbles poised at the edge of a gorge than a timeless monument, or even a book. But don't take my word for it. Allow me to quote Holst at length; here is a characteristic passage chosen almost at random:

> It is something! these rare occasions – and this is one of them – when a fresh breeze blows in off the Atlantic and fills the streets of New York City so that an afternoon in June becomes the epitome of something, and something in everyone arises to the occasion.
>
> Isadora Duncan. Martha Graham. Merce Cunningham. Not unlike those troops of previous eras that become sets of toy soldiers, whole sets of troupes of modern dancers now flood the Christmas toy market. It is noted with amusement and amazement – but without comprehension – that boys, as well as girls, like to play with the troupes of dancers, and that they are toys that boys and girls play with together. But note that

significance: like the first step in a performance of a complicated dance it may mark a first sign, an initial intimation, a revelation in miniature of the peaceable nature of man – a noteworthy minor beginning of peace without end among men of all nations.

He builds a flamboyant chandelier that sets aflame stars at the ends of its arms, builds beauty with bits of cobalt glass that can tinkle in a breeze, and sends solid black shadows of trembling shapes and bright purple forms dancing on white walls, where crystals coalesce into worms of light and rainbow-splash from candles swinging in porcelain cups of fragile freckleware.

The Pocatello Idaho Potato Parade is led each year, not by a Queen, but by the King of Potatoes, carried not by a coach, but by white horses drawing a perfectly plain, open wooden wagon, perfect for the display of a gigantic potato.

Hunger of the fishmonger for a good steak is his motivation for breaking the law, for being a thief, so that he could sit in a regular restaurant, first having something strong in a small glass, before eating red meat, that would be capped by a beautiful giant Portobello mushroom.

Ordinarily, I begin a letter one of two ways, either with reference to an intimacy shared by my correspondent or with what would otherwise be the bottom line. The first mode of address applies to relationships of affection, the second to formal transactions. In this case, neither pertains; I don't know Spencer Holst, and since one of us is dead, a transaction (or a reply of any kind at all) is a highly unlikely outcome. So I've begun instead by sidestepping and quoting. I imagine Holst would argue that a peculiar circumstance warrants a straightforward approach, beginning with the matter of beginning and ending there, too. A complete idea from him typically takes the form of a sentence or a short paragraph, like those above, or like so:

A boulder is transported a great distance on an Ice Age glacier which on melting drops the erratic traveler in what is to become a Massachusetts meadow, places it precisely atop a smaller taller rock, where it remains balanced for ten thousand years. During that time the surface of the bottom rock becomes completely covered with a thick mat of dark green moss, while brilliantly colored yellow, orange, purple and red lichen grow all over the larger stone.

If I were Holst, or more like Holst, I would simply begin again now with a fresh line or new paragraph on baseball or magic or the colour orange, for example, without ever returning to reincorporate a Massachusetts meadow. (Holst: "With a perfect snap! he throws his fingerprints off his fingertips.") I'm not much like him, though. I take after Orpheus, always peering over a shoulder into the murk behind me, trying to discern a figure there ("there" being Massachusetts in this instance, home of Holst's traveled boulder and,

incidentally, the ancestral French family), while Holst, who favours Eurydice in my analogy inasmuch as he is profoundly unavailable, eludes exactly that sort of glance. All of the preceding paragraphs are excerpted from a piece or a series of pieces (are they stories? essays? notes? texts?) called *Balanced Boulders*, subtitled "384 Unconnected Paragraphs In Six Parts". According to Holst's notes to the illustrations that accompany the edition published in the collection *Brilliant Silence*, which are photographs of rocks improbably balanced atop one another made by an artist and friend of Holst's, George Quasha, "… Axial Stones have a reality that is far beyond what can be conveyed by pictures." Quasha's photos of balanced boulders are the visual corollary to Holst's printed pages.

Deep in the woods, a lost hiker or hunter is surrounded by food and other supplies necessary for survival, all free for the taking. But how many know to recognise the available resources? How many have the skills to identify nutritious, fatty insects? How many can say which vegetation is edible and which will also prevent scurvy? Who can make a compass from a needle, the small amount of oil wiped off the surface of her forehead, two blades of grass, and a little pool of water? (Who happens to carry a needle on a hike?) With only a bit of relevant knowledge, one can survive alone in the wilderness indefinitely. Or one can perish rather quickly from ignorance. As Holst's reader, I felt at first like an ignorant hiker, physically fit but mentally unprepared. No map of his terrain, nothing of the sort I'm accustomed to picking up automatically from other writers, would impress itself upon my brain. I could take in only one or two pages at a time before growing tired.

He makes a turban out of a patchwork quilt and wears a bulletproof vest in order to walk without injury into a Texas hailstorm. His toes sticking out of his sandals are the only vulnerable targets for the walnut-sized hailstones, but soon he has four broken toes – on each foot – and he stumbles in pain, falls to the ground, and finds it impossible to reach the other side of his backyard to save the chickens from certain death.

I would not manage to save the chickens, either, if my chickens were narrative coherence and emotional registration.

I spent two days rock climbing with a handful of friends once. I hadn't initiated the trip or made the arrangements, so I didn't have a clear sense of what was in store. In my naiveté, I anticipated a two-day hike interrupted by an occasional boulder, the way an occasional water feature might interrupt a pleasant garden path, adding a coy element of "safe danger" to an entirely safe experience. Imagine my surprise on day one when the hired guide of our small group, a man named Bill, distributed helmets and harnesses and, after tethering us to a constellation of large rocks and double-checking our rigging, instructed us to step backwards off a cliff the size of a townhouse. By the second day, we were following Bill on what is called a "multi-pitch" climb up the side of a mountain wall more than 200 feet high. In this case, we were tethered to one another. Bill went first, inserting steel pins into

cracks in the rock face, through which our safety cables were threaded as we trailed behind him. Not quite halfway up the cliff, my psyche split neatly in two. I began a conversation (aloud) between a frightened child and a coaxing parent, fully inhabiting both roles at once. It was necessary to talk to myself as this pair in order to progress upward at all, an inching I achieved only by way of minute movements, every muscle of my body rigidly flexed in an effort to defy gravity and stick to the mountain.

for a stranger who will read aloud, and to one who listens – this book is dedicated; but then … to such a pair all of literature is dedicated.

Exoskeletal and supremely focused, I became an insect, albeit a self-aware one, which is to say an utterly terrified one. I spent most of the day aquiver, despite the unmitigated late-summer sun overhead. Intellectually, I knew my safety equipment could be expected to save me if I were to lose my footing. Physiologically, "safety equipment" was just another string of meaningless sounds. At the top of the cliff, Bill, who had begun climbing as a teenager almost three decades earlier, informed me that I would be rappelling down the rock, and that the first 40 feet would be a straight descent, since the rock face would be too far from the edge of the precipice for me to reach with my toes. Bill barely spoke, but he had a solid knack for timing a delivery. In fact, his entire pedagogical approach amounted to a spare and rather elegant form of information control. I asked if there were some other option, like walking down the backside of the mountain on foot. Bill squinted into the distance, the opposite direction of the backside of the mountain, and paused for effect, as if he were considering the possibility, though he was probably thinking about something else. He shook his head, "No trails. It'll take you two days." No invitation to further discourse followed. A minute later, I pushed myself away from the mountaintop into an invisible net of thin air and trust, well above the tips of the tallest trees below. There, spinning 360 degrees on a thread at the start of an anticipated freefall that never occurred, I finally exhausted my capacity to fear the circumstances, and gave over instead to the exquisite, effortless pleasure of floating in the part of space-time that extends infinitely before the end of our mortal lives. The ensuing endorphin high lasted nearly two weeks, during which time I seriously considered decamping to the mountains to take up the sport full-time, inasmuch as I was capable of seriously considering anything at all from that ecstatic state of mind and body. What I experienced that day was a kind of learning that couldn't be anticipated or taught.

The turtle paddles upon a pond staring up at a crisp crescent moon in the deep blue sky, its neck stretched out into the air, and then it dives down and swims along the gravel bottom among the fixtures of the fish, among those uncanny pairs of stones, one balanced on the other, that sit in the sand like underwater furniture – the whole scene being the set for a Lincoln Center

dance concert in which my reader takes the lead and dances the part of the turtle, the author being your audience.

Gravity is the medium of dancers. They inhabit its truth with acute bodily awareness. I wrote to renowned choreographer Yvonne Rainer about Holst after learning from a show bill in a New York archive that they had worked together. "Dear Yvonne Rainer, so-and-so gave me your email address so that I could contact you regarding Spencer Holst." She replied immediately to say she couldn't remember exactly how she met him, but that he "freely gave" permission for her to use two of his texts in a 1963 performance at the Judson Memorial Church of a piece called "Terrain" in which six dancers combined recitations with movement in a series of solos. That was fifty years ago. What did he sound like, I wondered. How did he speak? How did he move?

He was a very short elf-like man. I was drawn to the whimsy of his writing. The recitations ran independently of the dance movement but occasionally, and fortuitously, converged, as when the dancer uttered the lines "My father told me that he remembers when he was a child that my great-grandmother used to bake huge round cookies, and no matter what animal my father named, my great-grandfather could quickly bite the cookie into that shape." Naturally, at that moment, whatever "shape" the dancer embodied mimicked the words.

I learned from Rainer that Holst's small body of short works matches what was his body – not as frivolous an observation as it may seem, considering his predilection for characters whose physicality or physical predicament conveys all there is to know about their stories, as in, "It's hard to hold a hammer with your arm in a sling while carrying a gong during the rush-hour on the subway in Tokyo." Characters don't do much talking in most of Holst's tales. Instead of telling, they are themselves told, which has the knock-on effect of turning elements of a scene into characters, as well, since a house or a tornado or a fish, like a man, is each built of the same basic material, and finished from the same palette, as in, "The bloodthirsty macaw that killed raccoons spoke Dutch" – a personal favourite from the category of preposterous stories composed of fewer words than the category description itself.

Occasional, fortuitous convergence; whimsy; what you remember as a child: are these synonymous? In a memory that may be a dream, I am walking through shady pinewoods behind my grandparents' house when I come upon a circular clearing coloured by bright warm sunlight. That's the whole story. I am walking in a place I know well, the light changes, I'm in a place I haven't been before. End. This memory comes to mind with some frequency, though I can't be sure whether it appears once every few weeks or once every few years, only that it returns rhythmically from wherever it is lodged, and as it does, it marks a tempo too slow to track. The vision – and it is a vision, nothing more, nothing less – is as uneventful as it is vivid.

Here's another Holst story: "When I write, I worry about what things mean, but when I paint, it's just dab … dab … dab … dab … " I don't believe it. It isn't evident that Holst worried much about what his stories meant, for one, though he may have worried plenty over their syntactic viability. His phrases and paragraphs are carefully formulated, but they seem to mean only as much as visions. That is, they simultaneously mean plenty and not much at all, in the way of riddles and koans. Too, words are dabs – fingerprints with a shape and colour of their own, independent of a writer's conscious intentions or worries. In the case of a storyteller whose word was primarily embodied in voices, gestures and ears, these prints are even more visceral than their typographic counterparts. They smudge and all but disappear when the voice stops and its audiences disperse, forget and die. The same words may remain on a page, bound between covers, sorted on a shelf, but they do not adhere as texts so much as scores. They lie fallow for bodies to revivify.

I searched for Holst's fabled voice, but discovered only that a few questionable tapes exist beyond reach in an archive somewhere in Texas. The single audio sample I wrangled from the internet was of a 1972 performance from poet Jackson Mac Low's *Stanzas for Iris Lezak* that involved multiple readers and noise-makers, one of whom is Holst, though I don't know which. His sound and intonation match either a nasal-inflected security guard type, or a newscaster from the age of Edward R. Murrow, or a plaintiff's lawyer in a courtroom drama, though none of these options match his elfin physique. Perhaps he is the speaker who comes in close to the end – the mellow middle tone with a barely detectable lisp, whose delivery conveys a paradoxically disconcerting and soothing immediacy, rather than an overtly dramatic persona. The voice belongs to a stranger who leans over unexpectedly to say something in your ear, but who finesses the invasion so smoothly that your defenses aren't provoked. I could contact one of the other, still-living voices to ask who's who, but I'd rather let Holst bounce among the possibilities, while remaining approximate, indefinite.

Although it's on the edge of my consciousness, although it's on the tip of my tongue, I know it's gone forever. Last night I awoke several times with the same dream – on a blazing desert I heard a lovely voice pronounce the title for this book, but now I can't remember it and I know I never will. On a blazing desert I've been deserted by that voice, and must now be satisfied with the desert's brilliant silence.

A few nights ago, I dreamed a beloved aunt recommended that I dye my eyebrows pink. She had done that, herself, in my dream, and the look did flatter her. I thought she was the most beautiful woman I had ever seen, and I told her this, which is something I've heard small children tell their mothers. They always mean it. The most-ever happens every day when you have almost no experience. Each encounter with a new most feels magical, in a way that is specific to early childhood. That same stock of magic dust coats Holst's stories,

even when they're not strictly about magicians: "If you've never swallowed a gumball you won't know what I mean." Or –

> He built his house over the elevator shaft of an abandoned salt mine, and in his house there was a small room whose only window was a trap door in the floor. He was a collector of cymbals, and whenever he got hold of a cymbal he would drop it down the shaft, and listen to it echo as it fell. He was a writer like me.

Anyone can describe gravity's effect. Few can convey it.

Angie Keefer (b.1977) is an American artist, editor and teacher living in Upstate New York.

Silence/Noise

David Antin

THIS IS NOT GOING TO BE AN ARTICLE ON ESTHETICS
 THERE ARE VERY FEW THINGS WE NEED LESS
THAN ESTHETICS PERHAPS ONLY TASTE

THERE IS NOTHING WE NEED LESS THAN TASTE

WHAT WE NEED TO KNOW ABOUT POETRY IS NOT
WHAT MAKES IT DIFFERENT FROM PROSE IF WE
DON'T THINK THERE IS A DIFFERENCE THERE ISNT
ANY WHAT IS THE DIFFERENCE BETWEEN A LEAK-
ING CUP AND A STRAINER WE DON'T NEED ANY-
ONE TO TELL US HOW TO CONTROL THE LINE OR
COMPOSE A PIECE OF MUSIC WHAT WE NEED IS A
SURVIVAL TOOL WHAT I AM CONCERNED WITH
HERE IS SURVIVAL

I AM TALKING ABOUT LANGUAGE HERE A HUMAN
COMMUNITY CANNOT SURVIVE WITHOUT ITS LAN-
GUAGE LANGUAGE IS WHAT MAKES IT HUMAN
 BY DEFINITION LANGUAGE IS PUBLIC THERE
IS NO SUCH THING AS PRIVATE LANGUAGE
THERE ARE ONLY LINGUISTIC COMMUNITIES OF VA-
RIOUS SIZE IT IS HARD TO IMAGINE A LINGUISTIC
COMMUNITY SMALLER THAN TWO PEOPLE OR ONE
MAN AND A TAPE RECORDER THE SELF IS A LIN-
GUISTIC COMMUNITY IN WHICH THE PRESENT AND
THE PAST TALK TO EACH OTHER INSIDE OF ONE
SKIN

THERE IS NO NEED TO ASSUME THAT POETRY NEEDS
TO RECOGNISE ANY CONSTRAINTS BEYOND THE FUN-
DAMENTAL CONSTRAINTS OF LANGUAGE

HOW TO DEFINE A LANGUAGE DEFINE IT BY ITS
LIMITS SPEECH IS BOUNDED ON BOTH SIDES BY
SILENCE OR DEFINE IT BY ITS OBSTACLES IT IS
BOUNDED ON BOTH SIDES BY NOISE

NOISE/SILENCE carrying on a conversation with a friend
in my apartment in the summer a MR SOFTY truck de-
livers custard outside we speak ding we are ding
speaking we speak no longer the bell keeps ringing at
intervals ding after a while we do not hear the sound any
longer but i keep waiting for the bell to ring andhurrytospeak
after ward slowing before it ding comes again

again living in South Brooklyn which the real estate
agents have redesignated as Cobble Hill the children out-
side are Spanish and noisy but it is hot and i get an
air conditioner which makes a soft regular low-pitched
noise i no longer hear the children i hear the air con-
ditioner i hear nothing

silence

i turn off the air conditioner open the window i hear the
voices of children

NOISE IS THE SENSE OF A WINDOW IT IS UNDESIR-
ABLE SOUND IT IS DISORDER SILENCE IS CLOS-
ING THE WINDOW JOHN CAGE SAYS THERE IS NO
SUCH THING AS SILENCE NONSENSE IF THERE
WAS NO SUCH THING AS SILENCE HE COULDNT EVEN
SIGN HIS OWN NAME (he may not want to)

ABSOLUTE SILENCE IS ABSOLUTE ORDER IF IT
EXISTED ABSOLUTELY THERE NEVER WOULD BE ANY
SOUND ABSOLUTE NOISE IS ABSOLUTE DISORDER
 IF IT EXISTED ABSOLUTELY THERE NEVER

WOULD BE ANYTHING ELSE THE LAWS OF THER-
MODYNAMICS AND COMMUNICATION THEORY DO
NOT APPLY TO EITHER

THEOREM: THERE IS NO LANGUAGE OUTSIDE ITS
SPEAKERS

COROLLARY: DIFFERENCES IN LANGUAGE ARE DIF-
FERENCES IN THE ORDERED REALITIES OF THEIR
SPEAKERS

FOOTNOTE: "AN UTTERANCE IS AN IMAGE OF REAL-
ITY" WITTGENSTEIN

FOOTNOTE: "AN INCREASE IN COMMUNICATION
MAY MEAN AN INCREASE IN CONFLICT" CHARLES
MORRIS

ALL SPEECH IS AN ATTEMPT TO CREATE TO RECOV-
ER OR DISCOVER AND TRANSMIT SOME ORDER
YET ALL SPEECH GENERATES SOME NOISE TALK
IS CHEAP ALL IS COSTS IS NOISE IT MIGHT BE
WORTHWHILE TO CONSIDER HOW MUCH NOISE ANY
SPEECH GENERATES BEFORE SPEAKING

THAT AN ORDER DOES NOT EXIST ONCE AND FOR
ALL IS DUE TO TIME

FOOTNOTE: "INFORMATION (ORDER) INITIALLY ON
HAND LOSES ITS VALIDITY AS TIME GOES ON BE-
CAUSE THE EFFECTS OF AREAS OF INITIAL UNCER-
TAINTY ACCUMULATE AND PERMEATE THE WHOLE"

GLOSS: THERE ARE SOME STATES OF ORDER WE
CAN NEVER RECOVER HUMAN HISTORY IS NOT
ADIABATIC WE HAVE LOST THE RENAISSANCE

THAT NOSTALGIA FOR A LOST ORDER IS A FORM OF
NOISE THAT NOISE HAS USES IS FAIRLY OBVIOUS
TO WHOEVER READS THE NEWSPAPER OR LISTENS
TO PRESIDENTIAL ADDRESSES THEY CREATE A
BARRIER THROUGH WHICH IT IS NEARLY IMPOSSIBLE
TO HEAR OR SPEAK TO WRITE POETRY TODAY IS
TO ATTEMPT TO COMMUNICATE OVER A VERY NOISY
CHANNEL YET AS SHANNON HAS DEMONSTRATED
 IN THEORY IT IS POSSIBLE TO COMMUNICATE EVEN
OVER A CHANNEL OF NEARLY UNLIMITED NOISE
WITH SUITABLE METHODS OF CODING HOW IF
THE NOISY CHANNEL IS ALSO IN OUR OWN HEAD TO
DO SO

HOW TO CREATE AREAS OF SILENCE

THE MOST TERRIBLE EXPERIENCE OF THE LAST
THREE HUNDRED AND FIFTY YEARS HAS BEEN THE
GROWING CONVICTION THAT THE MOST SIGNIFI-
CANT ASPECTS OF REALITY HAVE BECOME UNSPEAK-
ABLE WITH THE CONSEQUENCE THAT THEY HAVE
ALSO COME TO FEEL UNREAL THEY ARE UNREAL

STATEMENT: I CAN CALL SPIRITS FROM THE VASTY
DEEP
QUESTION: BUT WILL THEY COME

THE FEELING THAT SOME/THING LIES OUT THERE
THAT WE CANNOT LAY HOLD OF IS THE FEELING OF
THE INADEQUACY OF THE EXISTING ORDER IT
IS THE DEMAND FOR A DIFFERENT ORDER THE
CONDITION OF POETRY THE NEED TO GAIN
GROUND

This text was originally published in some/thing magazine, issue 1, spring 1965.

David Antin (b.1932) is an American poet, artist and critic living in San Diego.

A Needle Walks into a Haystack is an exhibition of works that disrupt the way we assume our habits, and experience our habitats. Taking shape through different interconnected parts, it includes a group exhibition, four solo shows, an exhibition of works from a collection, art in public space, lectures, a performative weekend, and this publication.

The Old Blind School (former Trade Union Centre) features a group exhibition curated by Mai Abu ElDahab and Anthony Huberman with work by:

Uri Aran (b.1977, Israel)
Marc Bauer (b.1975, Switzerland)
Bonnie Camplin (b.1970, United Kingdom)
Chris Evans (b.1967, United Kingdom)
Rana Hamadeh (b.1983, Lebanon)
Louise Hervé (b.1981, France) and **Chloé Maillet** (b.1981, France)
Judith Hopf (b.1969, Germany)
Aaron Flint Jamison (b.1979, United States)
Norma Jeane (b.1962, United States)
Nicola L. (b. France)
William Leavitt (b.1941, United States)
Christina Ramberg (1946 – 1995, United States)
Michael Stevenson (b.1964, New Zealand)
STRAUTCHEREPNIN (Josef Strau, b.1957, Austria;
 Stefan Tcherepnin, b.1977, United States)
Peter Wächtler (b.1979, Germany)
Amelie von Wulffen (b.1966, Germany)

An exhibition of works by the painter **James McNeill Whistler** (1834 – 1903, United States) is presented at the Bluecoat curated by Mai Abu ElDahab and Rosie Cooper.

The work of filmmaker and photographer **Sharon Lockhart** (b.1964, United States) is on view at FACT.

St. Andrews Gardens houses the work of experimental film and TV director **Jef Cornelis** (b.1941, Belgium), including film selections made by Koen Brams and Dirk Pültau.

Dispersed around Liverpool are a series of new projects by **Christoph Büchel** (b.1966, Switzerland).

At Tate Liverpool is a group exhibition curated by Mai Abu ElDahab with Stephanie Straine comprising works from the collection by:

Ivor Abrahams (b.1935, United Kingdom)
Helena Almeida (b.1934, Portugal)
Richard Artschwager (1923–2013, United States)
Francis Bacon (1909–1992, United Kingdom)
Claude Cahun (1894–1954, France)
Patrick Caulfield (1936–2005, United Kingdom)
Marc Camille Chaimowicz (b.1947, France)
Saloua Raouda Choucair (b.1916, Lebanon)
Giorgio de Chirico (1888–1978, Greece)
Joseph Cornell (1903–1972, United States)
Keren Cytter (b.1977, Israel)
André Derain (1880–1954, France)
Sam Durant (b.1961, United States)
André Fougeron (1913–1998, France)
Naum Gabo (1890–1977, Russia)
Henri Gaudier-Brzeska (1891–1915, France)
Robert Gober (b.1954, United States)
Nan Goldin (b.1953, United States)
Spencer Gore (1878–1914, United Kingdom)
Philip Guston (1913–1980, Canada)
Richard Hamilton (1922–2011, United Kingdom)
Vilhelm Hammershoi (1864–1916, Denmark)
Susan Hiller (b.1940, United States)
David Hockney (b.1937, United Kingdom)
Sanja Ivekovic (b.1949, Croatia)
George Jones (1786–1869, United Kingdom)
R.B. Kitaj (1932–2007, United States)
Sherrie Levine (b.1947, United States)
Linder (b.1954, United Kingdom)
Andrew Lord (b.1950, United Kingdom)
Rut Blees Luxemburg (b.1967, Germany)
Lucy McKenzie (b.1977, United Kingdom)
Sylvia Melland (1906–1993, United Kingdom)
Rodrigo Moynihan (1910–1990, Spain)
Paul Nash (1889–1946, United Kingdom)
Gabriel Orozco (b.1962, Mexico)
Blinky Palermo (1943–1977, Germany) and **Gerhard Richter** (b.1932, Germany)
Claude Parent (b.1923, France)
Thomas Schütte (b.1954, Germany)
Kurt Schwitters (1887–1948, Germany)
Thomas Struth (b.1954, Germany)
Andy Warhol (1928–1987, United States)
Rachel Whiteread (b.1963, United Kingdom)

Also at Tate Liverpool is a new commission by architect **Claude Parent** (b.1923, France) titled *La colline de l'art*, built to house a display of works from the Tate collection by:

Anni Albers (1899–1994, Germany)
Carlos Cruz-Diez (b.1923, Venezuela)
Paul Delvaux (1897–1994, Belgium)
Naum Gabo (1890–1977, Russia)
Mark Leckey (b.1964, United Kingdom)
Roy Lichtenstein (1923–1997, United States)
Babette Mangolte (b.1941, France)
Gustav Metzger (b.1926)
Paul Nash (1889–1946, United Kingdom)
Francis Picabia (1879–1953, France)
Helen Saunders (1885–1963, United Kingdom)
Edward Wadsworth (1889–1949, United Kingdom)
Gillian Wise (b.1936, United Kingdom)

The Companion is a gathering of artists, thinkers, and performers accompanied by a music programme conceived by Mai Abu ElDahab and Angie Keefer taking place on 19–21 September 2014 and includes:

Mounira Al Solh (b.1978, Lebanon)
Federica Bueti (b.1982, Italy)
Jeremiah Day (b.1974, United States)
Josephine Foster (b.1974, United States)
Géraldine Geffriaud (b.1981, France)
Victor Herrero (b.1981, Spain)
Will Holder (b.1969, United Kingdom)
Angie Keefer (b.1977, United States)
Hassan Khan (b.1975, Egypt)
James Leary (b.1982, United States)
Lucy Skaer (b.1977, United Kingdom)
Jan Verwoert (b.1972, Germany)

This book is also a site of the Biennial.

Acknowledgements

A Needle Walks into a Haystack

8th Liverpool Biennial
5 July – 26 October 2014

Artistic Director
Sally Tallant

Curators
Mai Abu ElDahab
Anthony Huberman

Liverpool Biennial Curators
Rosie Cooper, Project Curator
Vanessa Boni, Public Programmes Curator
Polly Brannan, Education Curator
Ellen Greig, Assistant Curator
Simone Mair, Assistant Curator

Exhibition Design
Joseph Grima and Pernilla Ohrstedt

the Bluecoat
Bryan Biggs, Artistic Director
Sara-Jayne Parsons, Curator

FACT (Foundation for Art and Creative Technology)
Mike Stubbs, Director
Ana Botella, Programme Producer

Tate Liverpool
Francesco Manacorda, Artistic Director
Stephanie Straine, Assistant Curator

Liverpool Biennial Staff
Rachael Bampton-Smith, Marketing; Francesca Bertolotti, Head of Production; Emily Cruz, Development Officer; Zainab Djavanroodi, PA and Operations Executive; Louise Garforth, Head of Development; Elizabeth Hayden, Education Intern; Jane Howard, HR Consultant; Matthew Howard, Finance Assistant; Joanne Karcheva, Communications Assistant; Allison Mottram, Finance Officer; Sinead Nunes, Marketing Intern; Penny Sexton, Clore Secondment; Paul Smith, Executive Director; Zoe Thirsk, Business Development and Events Officer; Sally Thompson, IT Support and Franny Williams, Participation Coordinator.

Curatorial Interns
Elizabeth Edge, Jennifer Gleadell, Steven Hyland, Emma Kelly, Robert Larkin, Faye O'Neil and Natasha Peel.

Thank you
The curators would like to thank
the artists for their profound
commitment, as well as the
individuals, galleries, and museums
who lent works to the exhibition,
and the teams of Liverpool Biennial,
the Bluecoat, FACT, and Tate Liverpool
for making the show possible.
The curators would also like to
thank François Aubart, Stuart Bailey,
Jayne Casey, John Corbett and Jim
Dempsey, Claire Davisseau, Alexandra
Pacheco Garcia, Maia Gianakos,
Blanche Granet, Carol Greene and
Vera Alemani, Merlin James, Isla
Leaver-Yap, Margaret MacDonald,
Martin McGeown, the Mathematics
Department at Liverpool John Moores
University, Rosalind Nashashibi,
Naad Parent, November Paynter,
Jenelle Porter, Rolf Quaghebeur,
Chiara Repetto, Alex Sainsbury,
Sandra Terdjman, Harald Thys,
Vincent van der Marck, and
Margot Vanheusden.

Mai Abu ElDahab would like to
thank Benjamin Seror, Angie Keefer,
and Will Holder.

Anthony Huberman would like to
thank Juana Berrío, Thomas Boutoux,
Benjamin Thorel, Anthony Elms,
Larissa Harris, and Gedi Sibony.

Liverpool Biennial 2014 Supporters

Partners

the Bluecoat.

FACT

TATE LIVERPOOL

Walker Art Gallery — National Museums Liverpool

OPEN EYE GALLERY

John Moores Painting Prize 2014

Bloomberg New Contemporaries

Principal Funders

Supported using public funding by
ARTS COUNCIL ENGLAND

Liverpool City Council

EUROPEAN UNION
Investing in Your Future
European Regional Development Fund 2007-13

Founding supporter James Moores

Sponsors and Supporters

hope street hotel

BOODLES 1798

Bloomberg

METABOLIC STUDIO

With the support of the Flemish authorities

KADIST

The Granada Foundation

The Henry Moore Foundation

IFB2014.COM CULTURE

GOBIERNO DE ESPAÑA

AC/E ACCIÓN CULTURAL ESPAÑOLA

creative nz ARTS COUNCIL OF NEW ZEALAND TOI AOTEAROA

BRITISH COUNCIL

GRAHAM FOUNDATION

ifa Institut für Auslandsbeziehungen

PRS for Music Foundation

SALT

STANLEY THOMAS JOHNSON FOUNDATION

ERNEST COOK TRUST

FLUXUS

EMBASSY OF ISRAEL

swiss cultural fund in britain

GOETHE INSTITUT

LIVERPOOL ONE

Weightmans

restaurant bar + grill

PICCOLINO

WHAT'S AT SIXTYTWO

il forno ITALIAN RESTAURANT

THE NADLER LIVERPOOL

PREMIER APARTMENTS

TITANIC HOTEL LIVERPOOL

LIVERPOOL JOHN MOORES UNIVERSITY

LONMART INSURANCE

JAYHAWK FINE ART TRANSPORTATION

International.

CAMMELL LAIRD

CAMP AND FURNACE

steirischer HERBST www.steirischerherbst.at

BAREFOOT WINE

CLA Condy Lofthouse Architects

arciform

Commissions Partners

Leisure, Discipline and Punishment

Gallery Circle

Air de Paris
Dépendance
Greene Naftali
kurimanzutto
Lars Friedrich

neugerriemschneider
Pilar Corrias
Reena Spaulings Fine Art
Sadie Coles HQ

Patrons

Helen Ainscough
The Bloxham Charitable Trust
The Countess of Derby
Jim Davies
Simon Edwards
Anna Fox and Peter Goodbody
Nicoletta Fiorucci
Magnus and Elise Greaves
John and Ellie Greenslade

Jan and Mandy Molby
Barry and Sue Owen
Sue and Ian Poole
Daniel and Alison Rees
Paul and Elizabeth Reeve
Paula Ridley
Nicholas and Alex Wainwright
Peter Woods and Francis Ryan

Colophon

This book is published on the
occasion of the 8th Liverpool
Biennial, *A Needle Walks into a Haystack*,
curated by Mai Abu ElDahab
and Anthony Huberman,
5 July – 26 October 2014.

Commissioning Editors
Mai Abu ElDahab
Anthony Huberman
Camille Pageard

Managing Editor
Vanessa Boni

Editorial Assistant
Ellen Greig

Copyeditor
Jenifer Evans

Designers
Sara De Bondt and Mark El-khatib

Drawings
Abraham Cruzvillegas

Published by
Koenig Books, London
Liverpool Biennial

Printed by
Printmanagement Plitt,
Oberhausen

Drawings in this book are reproductions from the
series *Autorretrato con pulgar oponible* (2012), courtesy of
the artist and kurimanzutto, Mexico City; and from
the series *Autoportrait avec pouce opposable* (2013), courtesy
of the artist and Galerie Chantal Crousel, Paris.

Representations of an Intellectual: Professionals and Amateurs by
Edward Said. Copyright © Edward Said, 1993, used
by permission of The Wylie Agency (UK) Limited.

Liverpool Biennial
55 New Bird Street, Liverpool L1 0BW
United Kingdom
www.biennial.com

Koenig Books Ltd
At the Serpentine Gallery
Kensington Gardens, London W2 3XA
United Kingdom
www.koenigbooks.co.uk

Distribution
Germany and Europe
Buchhandlung Walther König, Köln
Ehrenstr. 4, 50672 Köln
Germany
Tel +49 (0)221 20 59 6 53
verlag@buchhandlung-walther-koenig.de

UK and Ireland
Cornerhouse Publications
70 Oxford Street, Manchester M1 5NH
United Kingdom
Tel +44 (0)161 200 15 03
publications@cornerhouse.org

Outside Europe
D.A.P. / Distributed Art Publishers, Inc.
155 6th Avenue, 2nd Floor
New York, NY 10013
United States
Tel +1 (0)212 627 1999
eleshowitz@dapinc.com

ISBN 978-3-86335-571-5